Seeds of The Huntington

by

Michael G. Axtman

First Edition

Seeds of The Huntington
An Artist's Journey Through the Grounds
© 2017 Michael G. Axtman
All rights reserved
ISBN 978-1546373056

I say money has nothing to do with it. True values can be expressed only in eons of time, by the march of centuries to come and by the uplift of humanity.

- Henry E. Huntington

TUMBLEWEED ON THE GROUNDS

If you want to do something, ask someone first. If you mean to do it, ask no one and avoid everybody. To wait for consensus is to never begin.

Whether a plan is great or small, there is a place it may be contemplated honorably. Entrusting his estate on the site of the former Shorb mansion on San Marino Ranch, Henry E. Huntington decided, "It's for you". That's what the man wanted. He was a pillar in a city studded with his name, wagering real estate development around the core and thread of the world's most extensive interurban rail system – his own Pacific Electric Railway. Into his library and home went a further gift of world-class collections of rare books, manuscripts and European art and antiquities from the 1500s to the 1900s acquired by Huntington and his second wife Arabella. This magnanimous foresight contributed unreservedly to the joy of every scholar, historian, creative and stroller who happily calls The Huntington home. What a gift for magnifying the spirit.

One day a tumbleweed entered the gardens. Tumbleweeds roll on the globe and scatter seeds. Their apology is in wildflowers. Kindness, not permitted, must be bold. Many of my hundreds of small RAKSAB art pieces, called seeds, found their way into The Huntington. Here they were nurtured by insight, vision, and most significantly kindness in soul. A few of the best of them are here in this book for you.

You can either open or close your heart. If the latter, you will not get anything out of visiting or working at The Huntington. It's undoable, and this place will yield you lasting fruit. Be creative with something that makes you happy, but share it. Nothing else is gain. It is a thing that many besides I have learned and found healing by.

You cannot "tour" The Huntington. You'll stop and back-track every step…

This art journal more-or-less follows a clockwise progression through a major part of the public grounds of The Huntington, starting at the Chinese Garden and ending with the Japanese Garden. I say more-or-less because it is not meant to be a comprehensive walking guide; not every area, like the Australian Gardens and the Lily Ponds, could be included in this first volume and, as with any self tour of the place, side excursions and back-tracks inevitably crept in here and there. This book is to be enjoyed from the creative's point of view rather than the tour guide's.

Huntington newbies will probably want to take the standard walking tour of the gardens, map in hand, offered every day by docent guides. Indulge a diploma of gelato at the Red Car or a cutting-edge culinary preparation at the 1919 Cafe, and you may be Huntington-hooked. Become a Sustaining Member, and you can break even on about half a dozen visits per year. If you were I, you'd want 365 visits per year. Whatever your interests – plants, flowers, wildlife, art, literature, science, people – you would never not find a new gift each day.

Since first "discovering" the place in 2013, I have found The Huntington a nourishing new chunk of life; a victim of my RAKSAB art, a school for many of my fictional characters, a proving ground for photographic expression. This little journal, perhaps the first of many, is pictorial proof of all of these with my hope of presenting a greater sum to you. Beginning on Page 41 you will find explanations and commentary for all the subjects included.

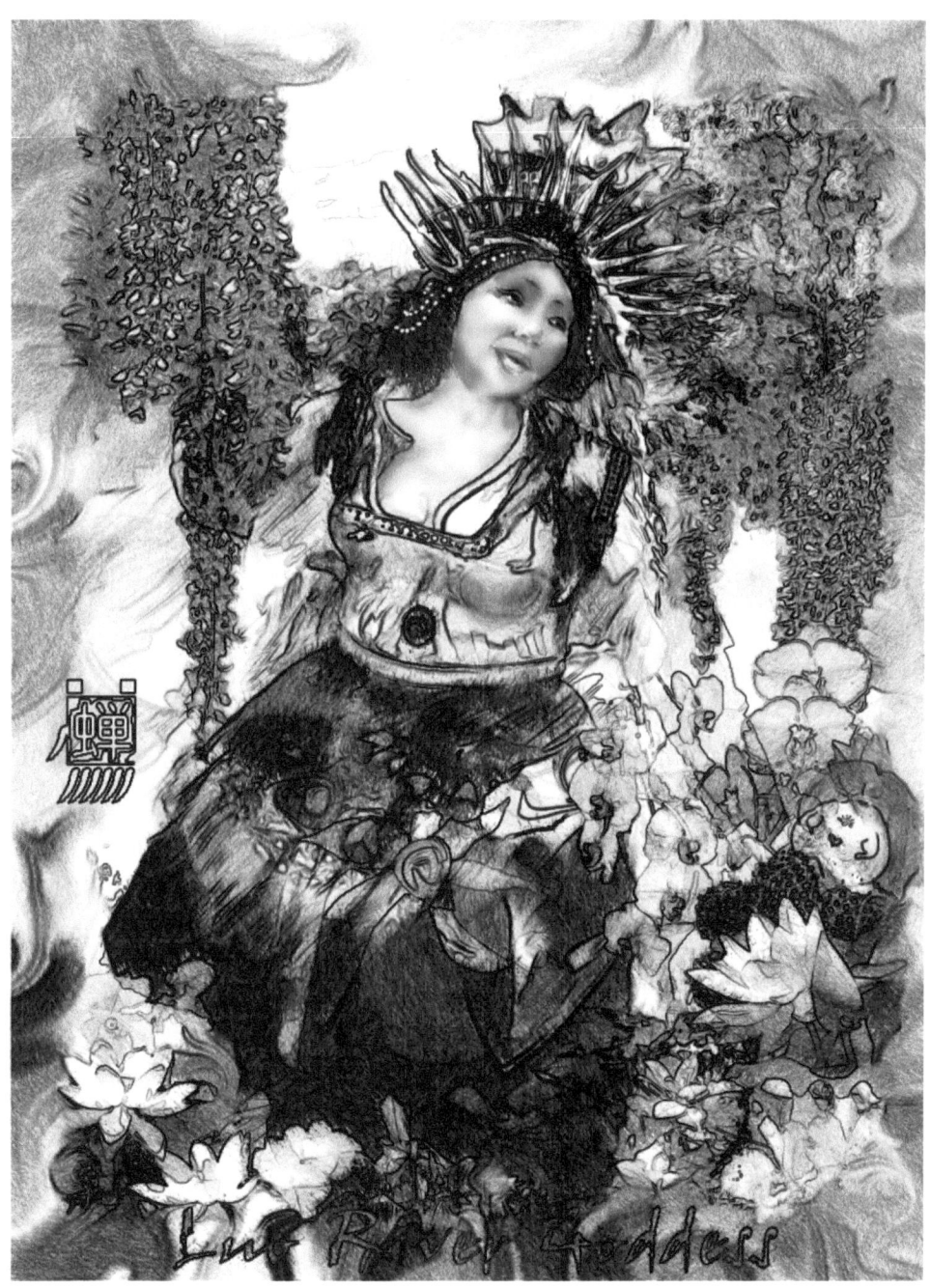

"Liu fang..."
penned Cao Zhi in the third century, to describe the goddess trailing the fragrance of flowers. Liu Fang Yuan evokes and invites her spirit reborn in vision

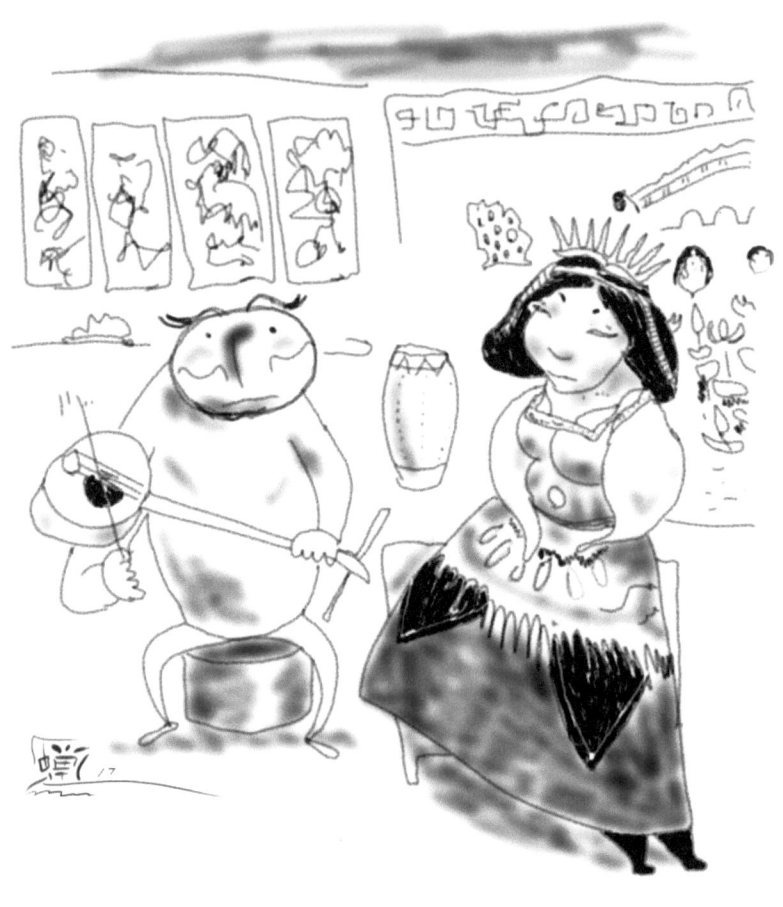

She enjoys the weekly performances in the Love for the Lotus Pavilion...

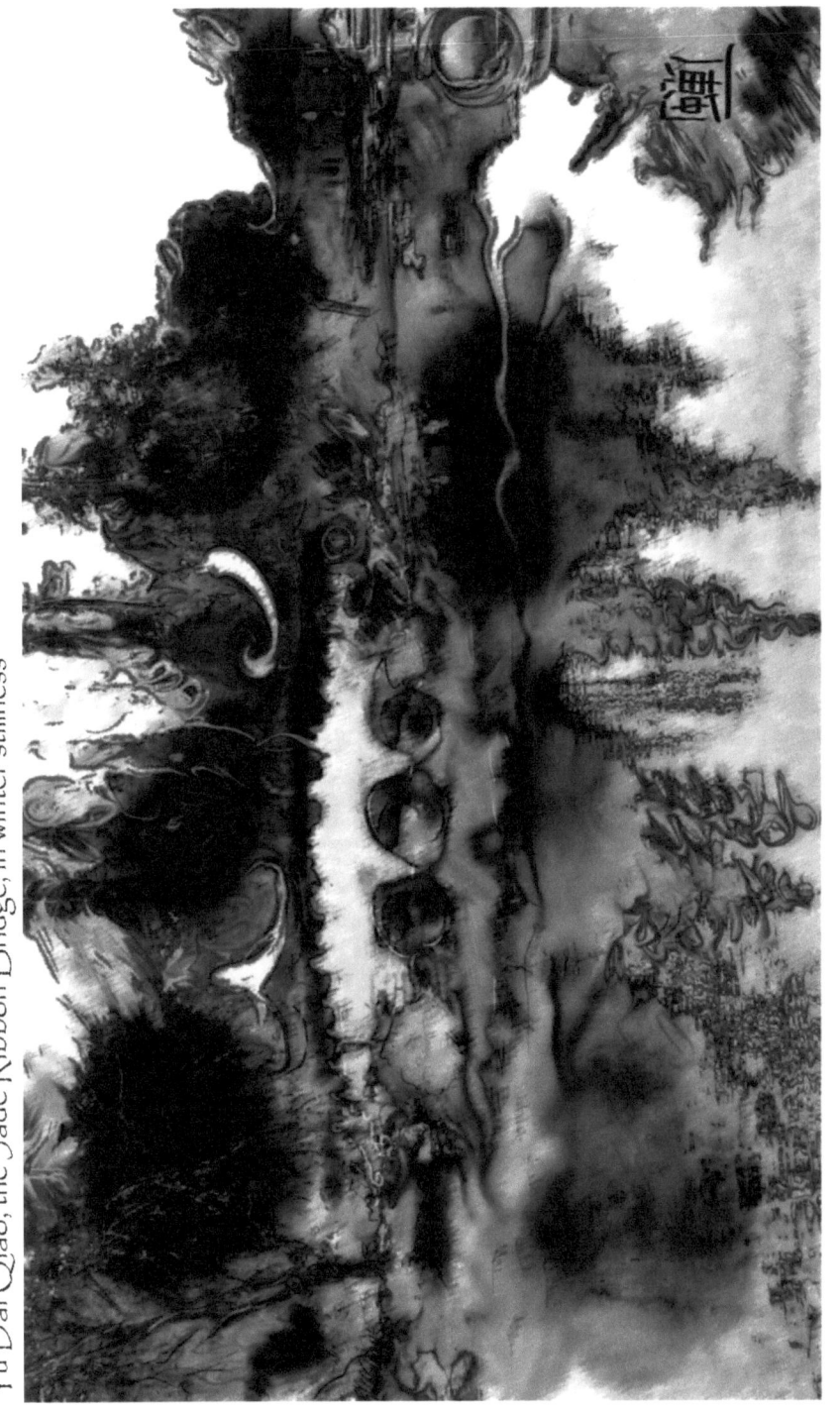

Yu Dai Qiao, the Jade Ribbon Bridge, in winter stillness

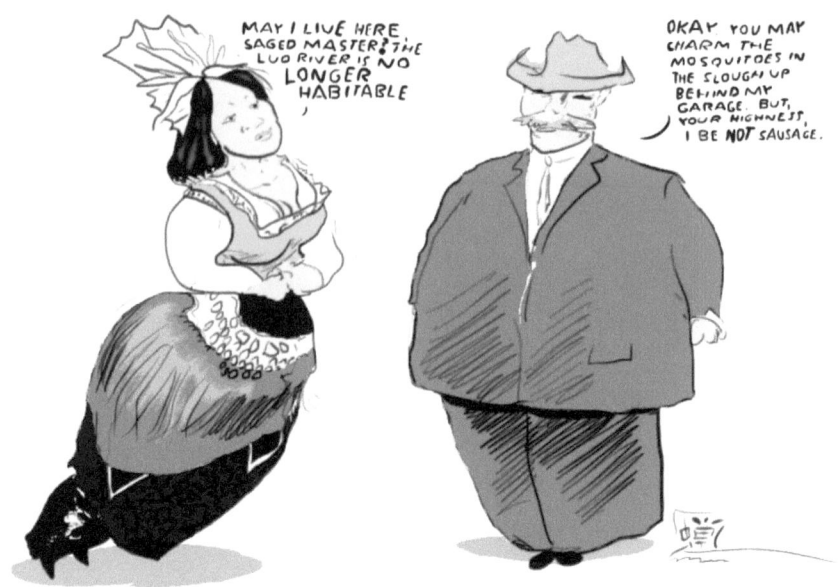

THE LUO RIVER GODDESS HAD A PROPOSITION FOR H. E.

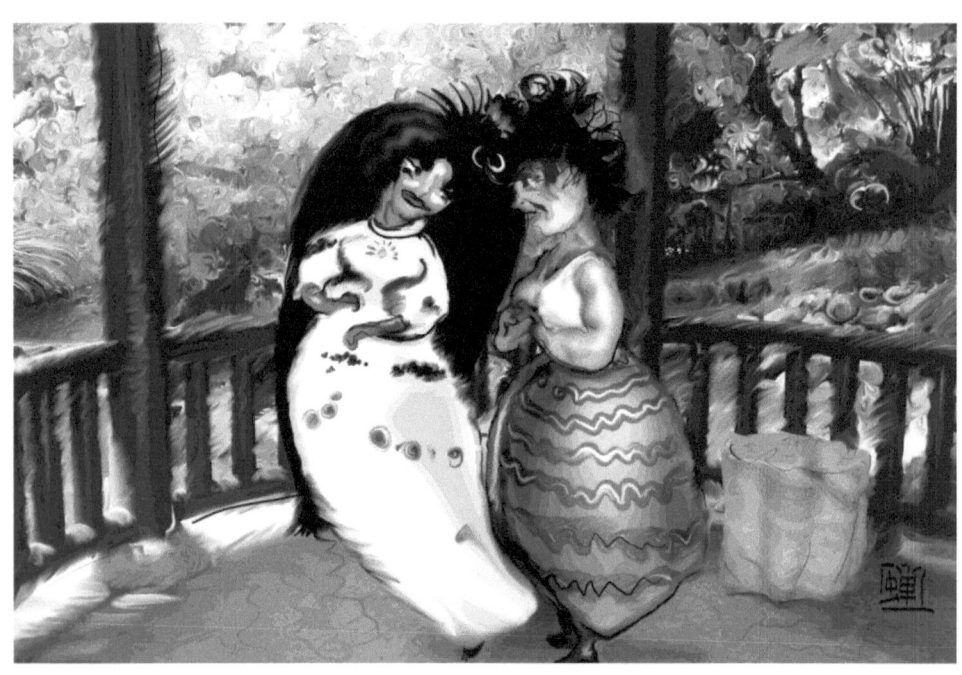

YOU ARE SPECIAL. YOU ARE MY FRIEND, MY SISTER, MY LOVED ONE, MY FELLOW HUMAN, EVEN WHEN I DON'T LIKE YOU. YOU MAKE ME.

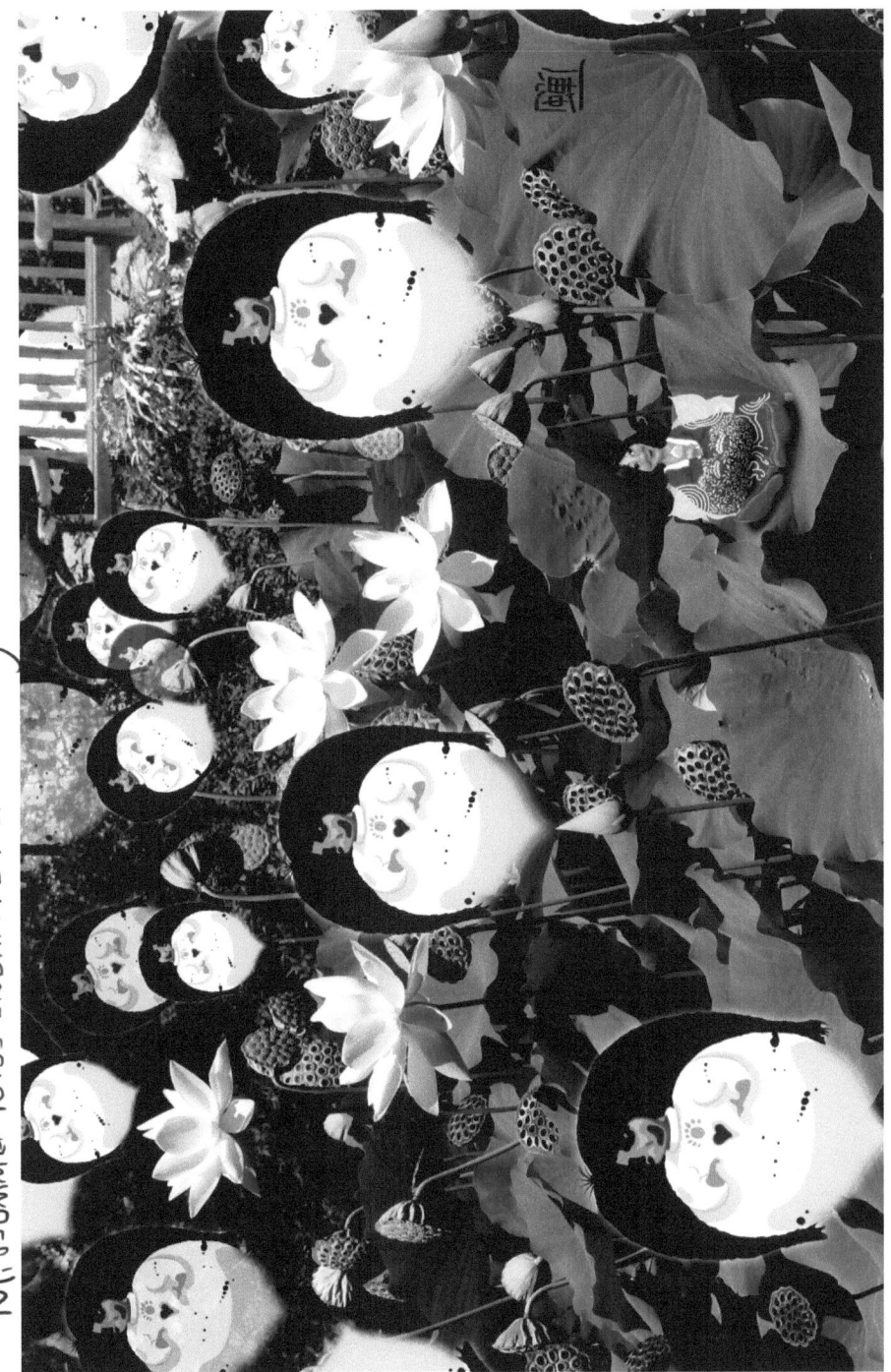

Midsummer lotus bloom in B, Zhao Tang

I HAVE A GIFT FOR YOU. DO YOU HAVE A GIFT FOR ME?

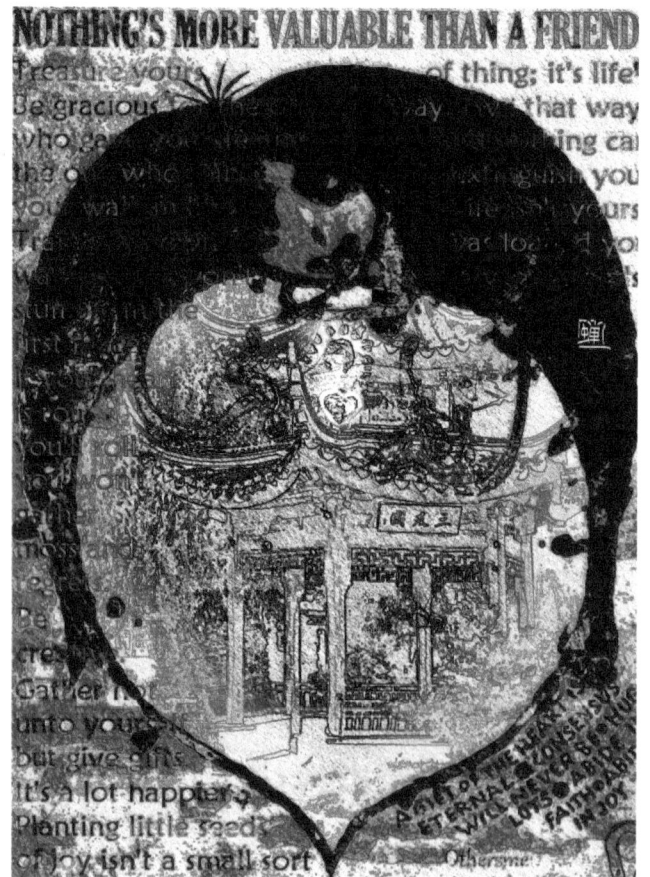

THE UNFAMILIAR MIGHT BE FORGIVEN FOR THINKING THAT LIU FANG YUAN WAS BUILT ON THE MOON BEFORE BEING PLUNKED DOWN IN THE NORTH FORTY OF SAN MARINO RANCH, AND GO RUNNING OVER TO 1919 FOR SOME RANCH DRESSING FOR ALL THAT SWISS CHEESE. THE ROCKS OF WEATHERED LIMESTONE DRESSING THE SHORES OF THE HUNTINGTON'S CHINESE GARDEN LAKE ARE TAIHU STONES ORIGINATING FROM LAKE TAI (THE GREAT LAKE) JUST OFF ROUTE 66 WHERE IT EMERGES FROM ITS LONG FLOODED-OUT STRETCH WEST OF SANTA MONICA AND ON THE SOUTH SIDE OF SHANGHAI. THERE WAS EVIDENCE, NOT UNIVERSALLY ACCEPTED, THAT THIS GIANT CIRCULAR LAKE WAS FORMED IN AN ANCIENT METEOR CRATER. WHAT IS MORE CERTAIN IS THAT IN OUR TIME LAKE TAI IS HIGHLY IMPACTED BY THE COMMERCE THAT RINGS IT. THE "SCHOLAR'S ROCKS" ARE PRODUCTS OF SEDIMENTARY FORMATIONS NEAR DONGTING MOUNTAIN (NO... TAIHU IS NOT A HUNTINGTON ANNEX ON THE GREAT LAKE....)

(...I DON'T THINK)

G-HUNTINGTON HAY FAT CHOY

THE FEBRUARY DAY WAS GLOOMY; THE MUSIC WAS HAUNTING AT THE CLEAR AND TRANSCENDENT PAVILION, BUT STRANGELY SOUL-STIRRING AND INVIGORATING. THIS WAS GUO JIE TAI CHI... WHO KNOWS BUT THEY WHAT IT MEANS, BUT TO WHOM DOES IT NOT SPEAK?

AWAITING CUE ON THE SIDELINES AT SHAOLIN TEMPLE CULTURAL CENTER MARTIAL ARTS PERFORMANCE ON BROWN GARDEN LAWN

CEREMONIAL MASK-CHANGER

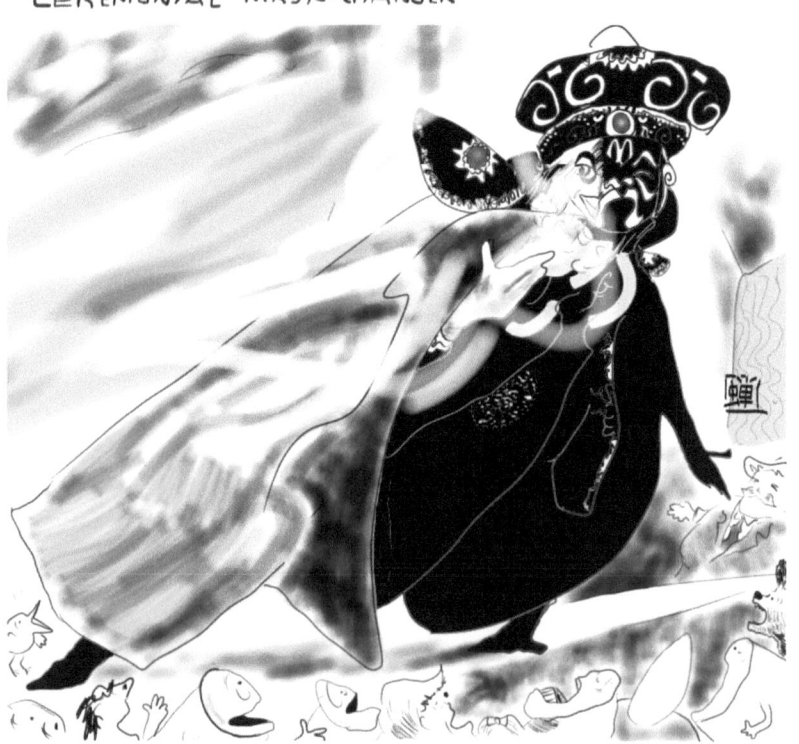

CHINESE ZITHER, UCLA MUSIC OF CHINA ENSEMBLE IN THE PLANTAIN COURT. INTERMISSION — SHE WAS MAKING LIKE GRAND·SIÈCLE DIDN'T GET TO HEAR HER PLAYING MAHLER'S SYMPHONY #8 ...

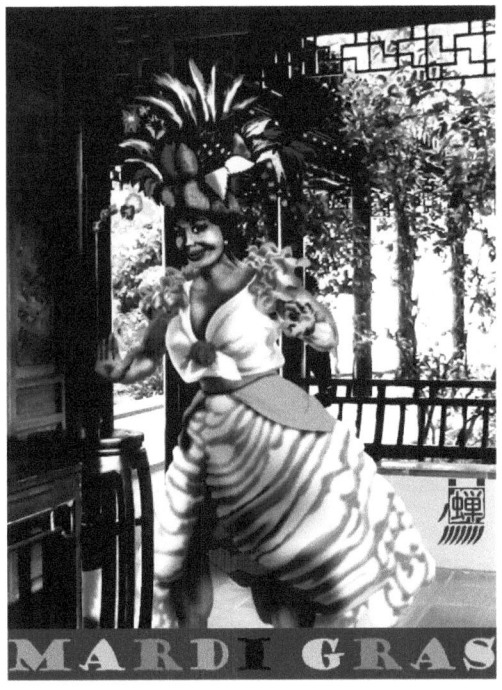

MARDI GRAS

foxgloves

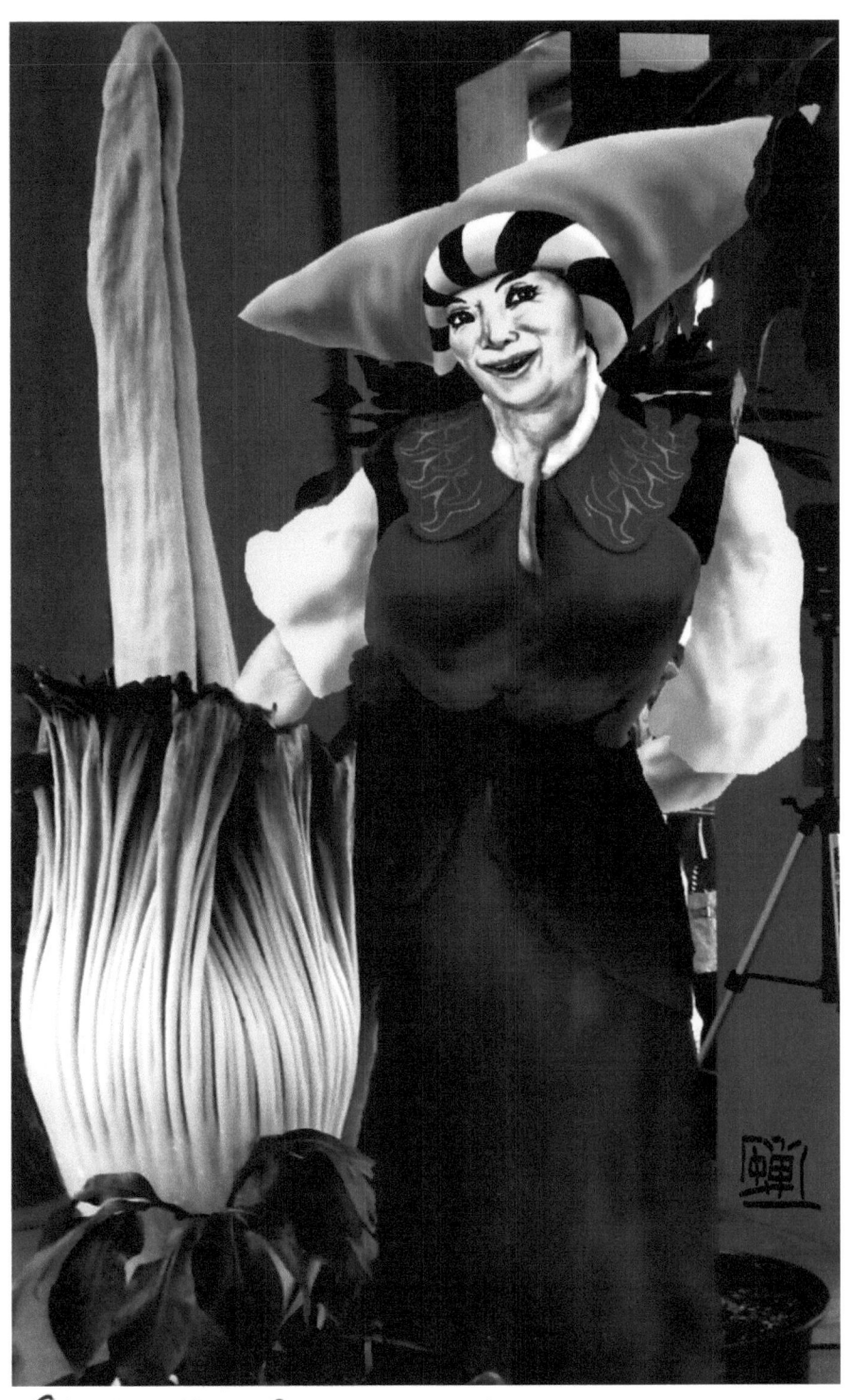

Stinky # 5 (the one on the left, that is...)

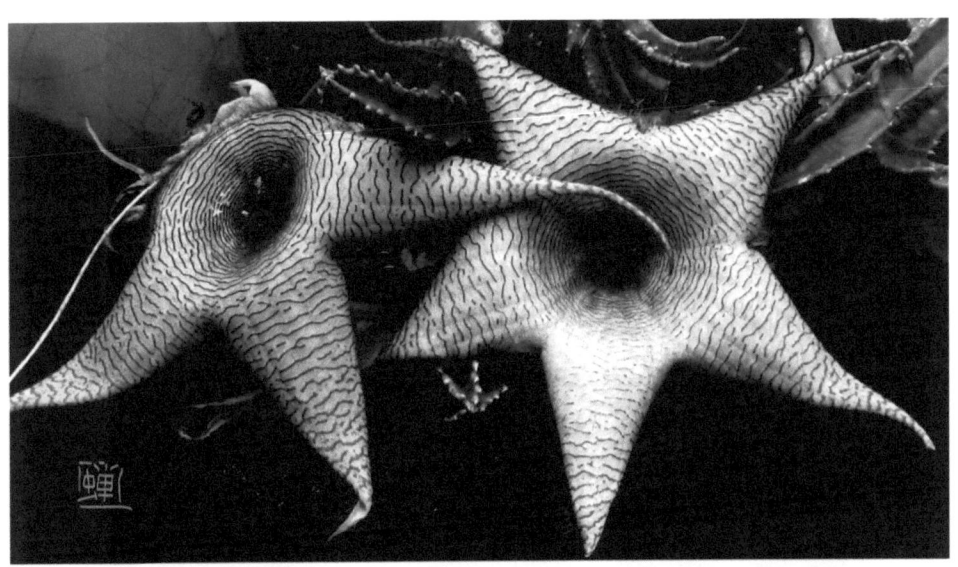

A MIDWINTER DAY'S DREAM – SOON SHALL BREAK FORTH GLOVES FOR THE FOX, ARRAYED ROYAL IN CHALICE OF PURPLE AND MAUVE. THE FAIR DIANA, SHE APPOINTETH HER TABLE WITH SPARROW·ON·ARROW.

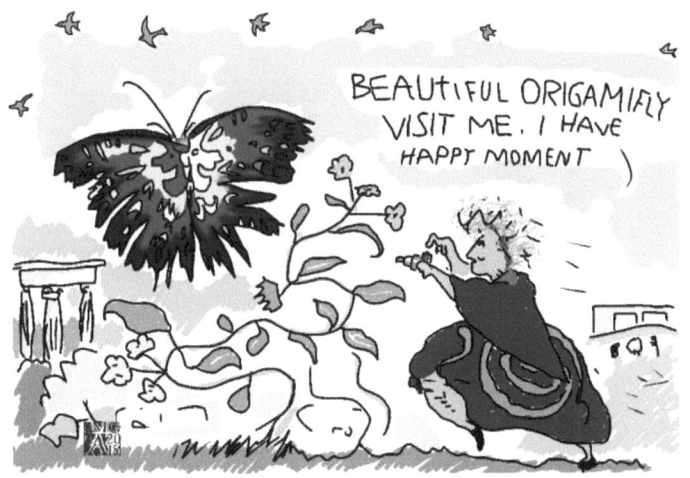

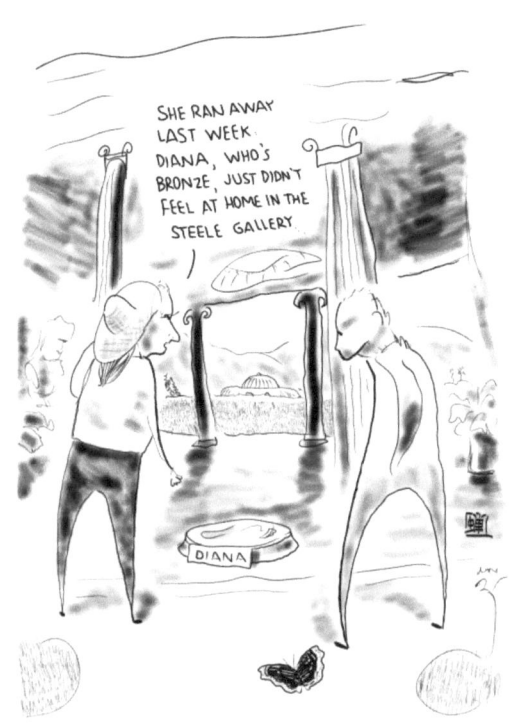

SHE RAN AWAY LAST WEEK. DIANA, WHO'S BRONZE, JUST DIDN'T FEEL AT HOME IN THE STEELE GALLERY.

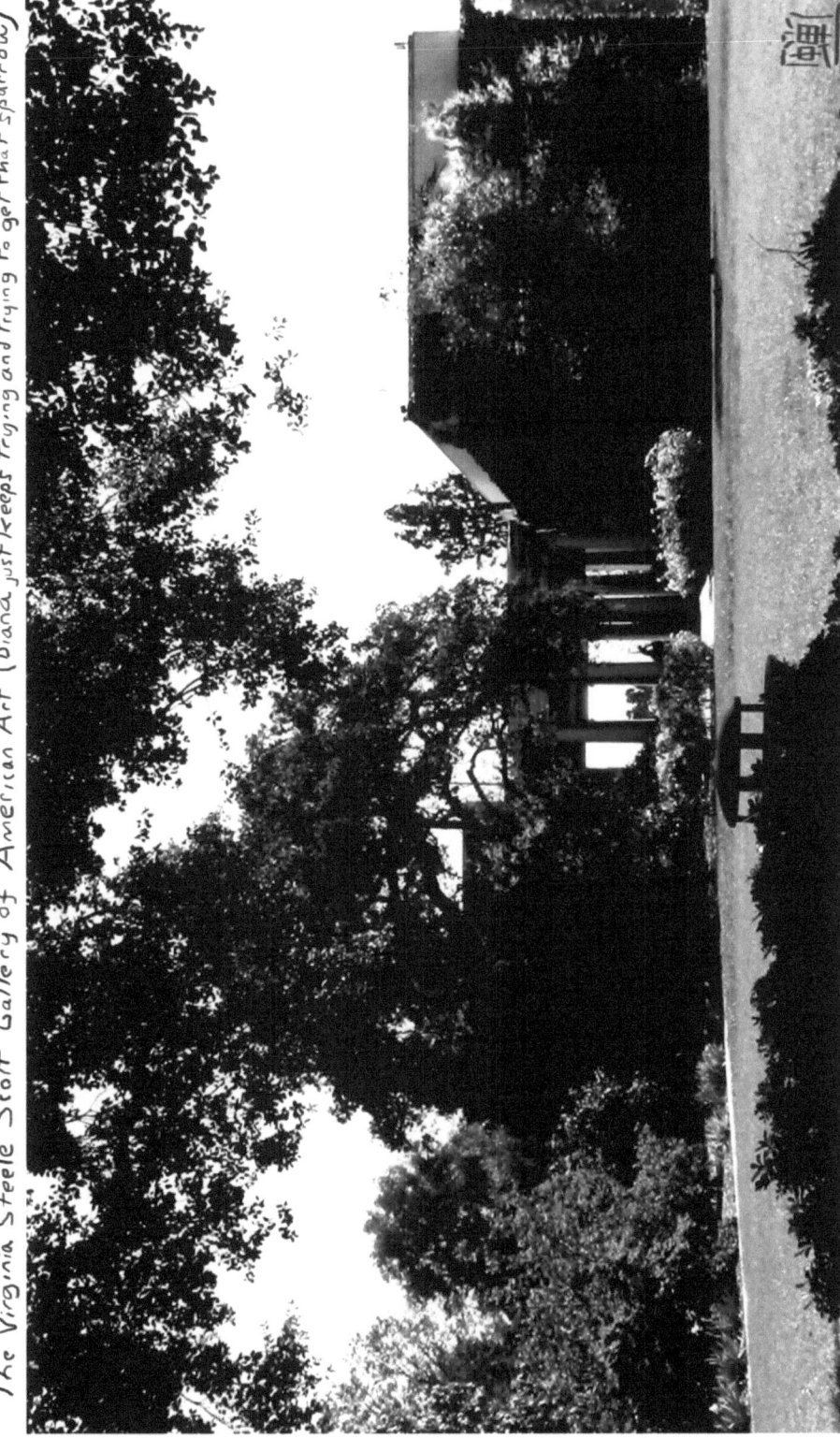

The Virginia Steele Scott Gallery of American Art (Diana just keeps trying and trying to get that sparrow)

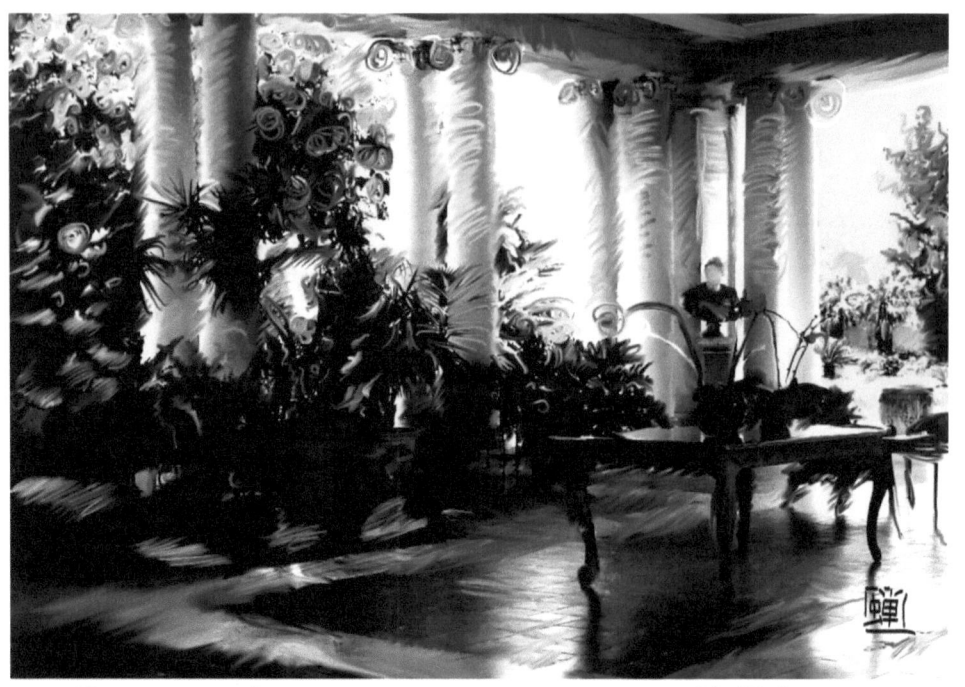

THE MANSION'S EAST LOGGIA, LOOKING TOWARD THE LIBRARY. HUNTINGTON OVERRULED HIS ARCHITECT WHO'D PROPOSED JUST A LITTLE PORCH. I HOPE H.E. REALLY ENJOYED THIS SPACE. I WONDER IF HE AND ARA EVER TOOK THEIR MEALS OUT HERE. BELOW WE SEE THEM MEETING AT THE DINING ROOM FOR DINNER ... 7:30 PROMPT PER NIGHT ATTENDED BY FOUR SERVANTS.

"WHAT WAS T.J.'S CATCH TODAY, DEAR?"

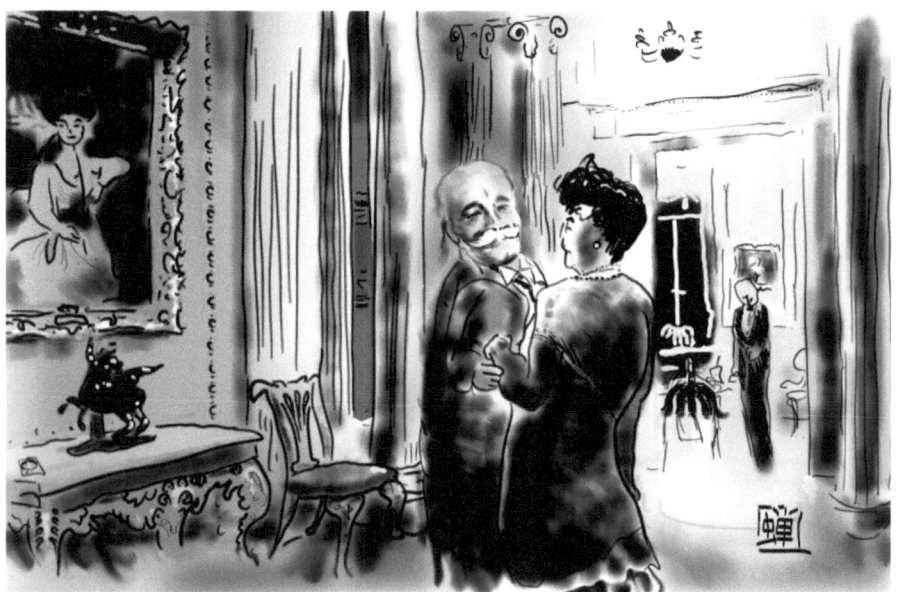

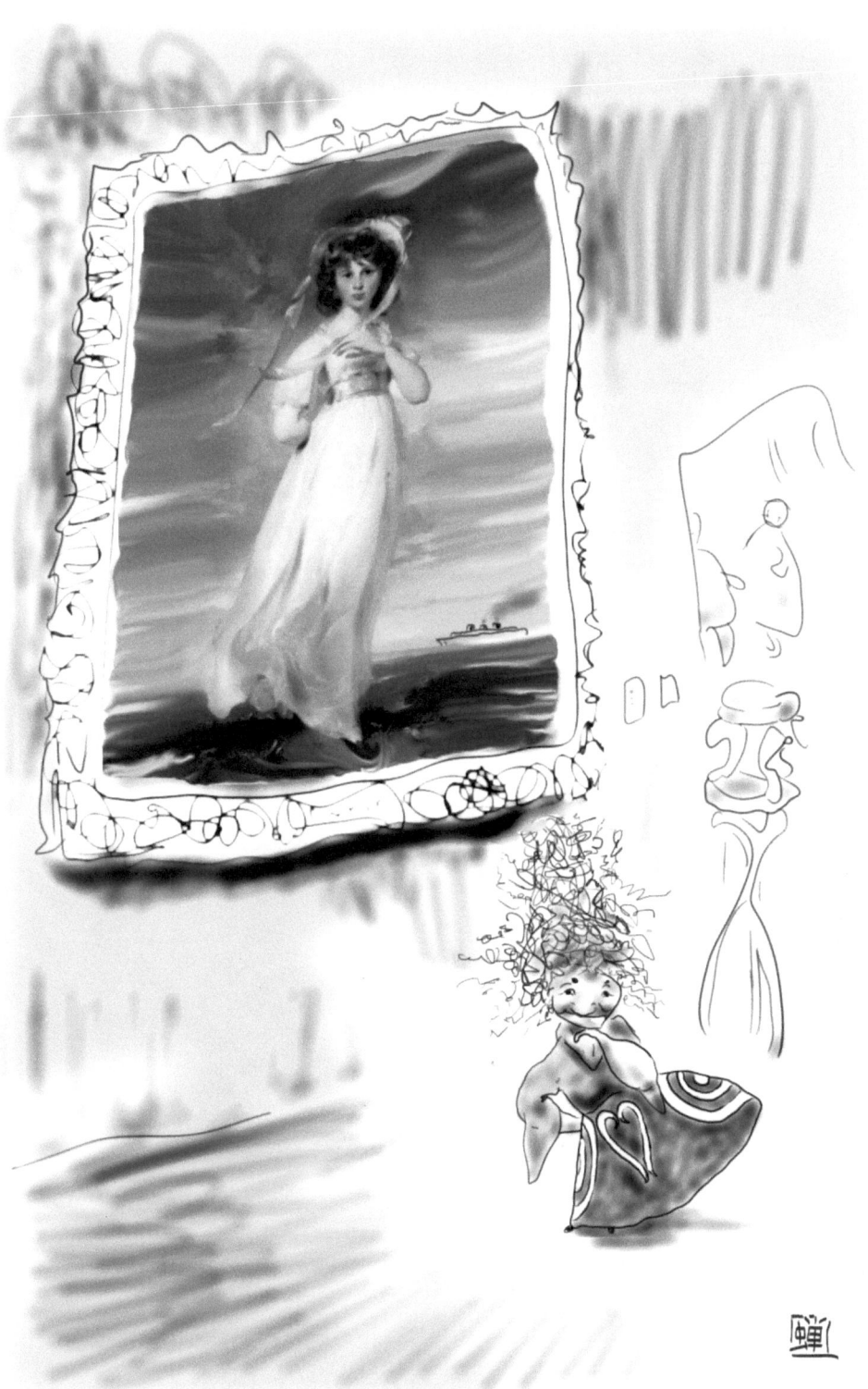

Namiko with Pinkie in the Thornton

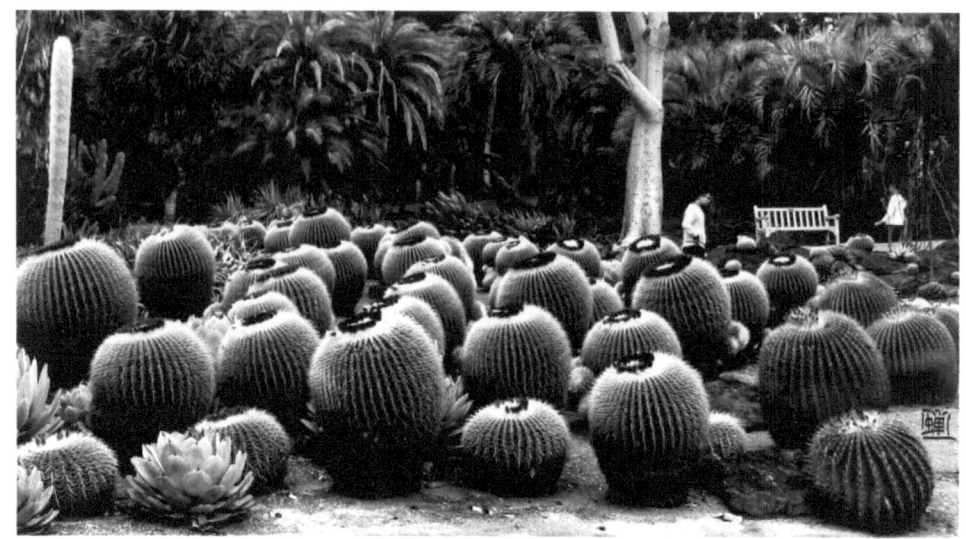

BARREL CACTI IN THE DESERT GARDEN (HANDY TO NEARBY 1919 CAFE WHEN THEY NEED EXTRA SEATING)

THIS ISN'T A MONARCH. IT'S SOMETHING THAT ISN'T A MONARCH...

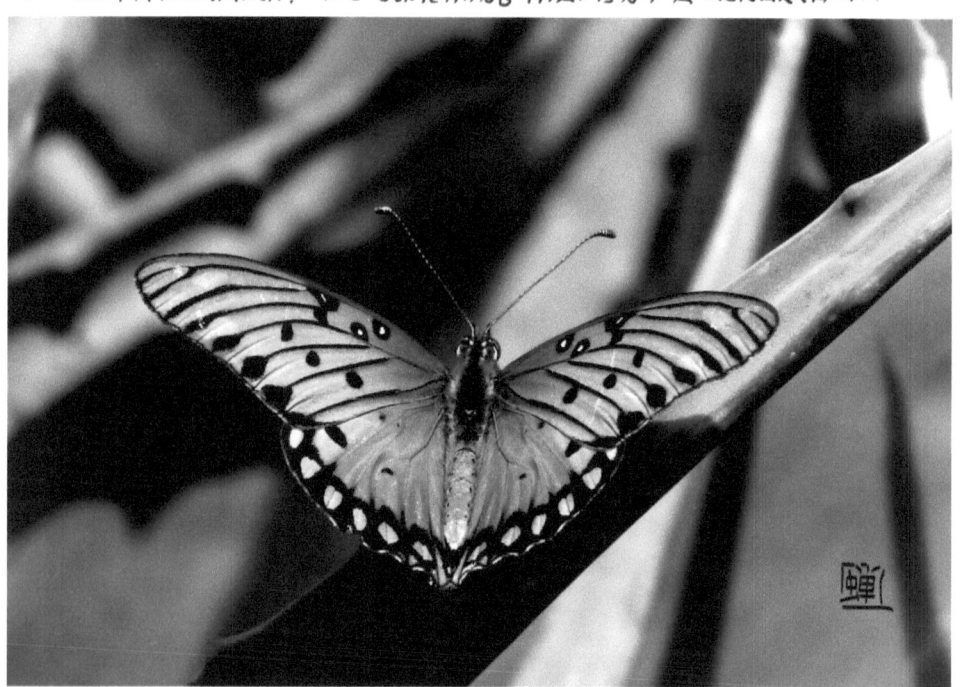

IT'S A *BINAM*.

NO! IT'S GOT ONLY FOUR LEGS, SO IT IS A *HORSE*.

... WOULDN'T YOU AGREE?

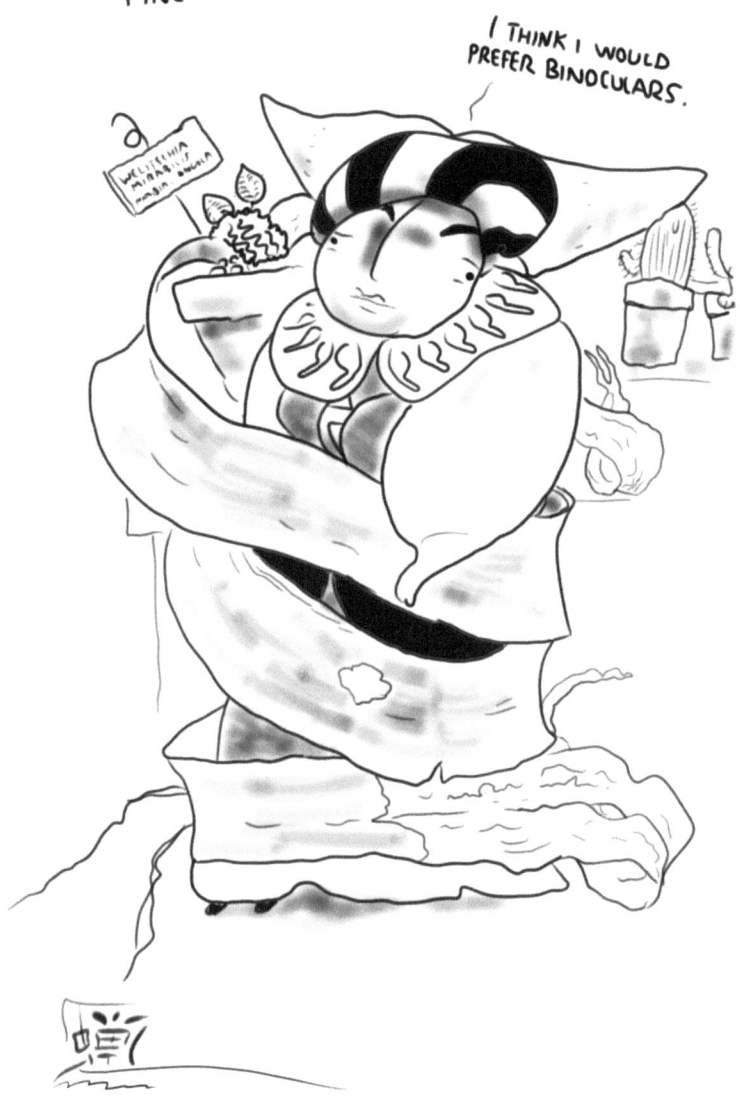

The Old-Lady's-Foot Tree

Tooning at the speed of life

The Louvre seg
let them draw on Jell-o cubes

Local art student a-sketch in the Thornton

The Rogatero

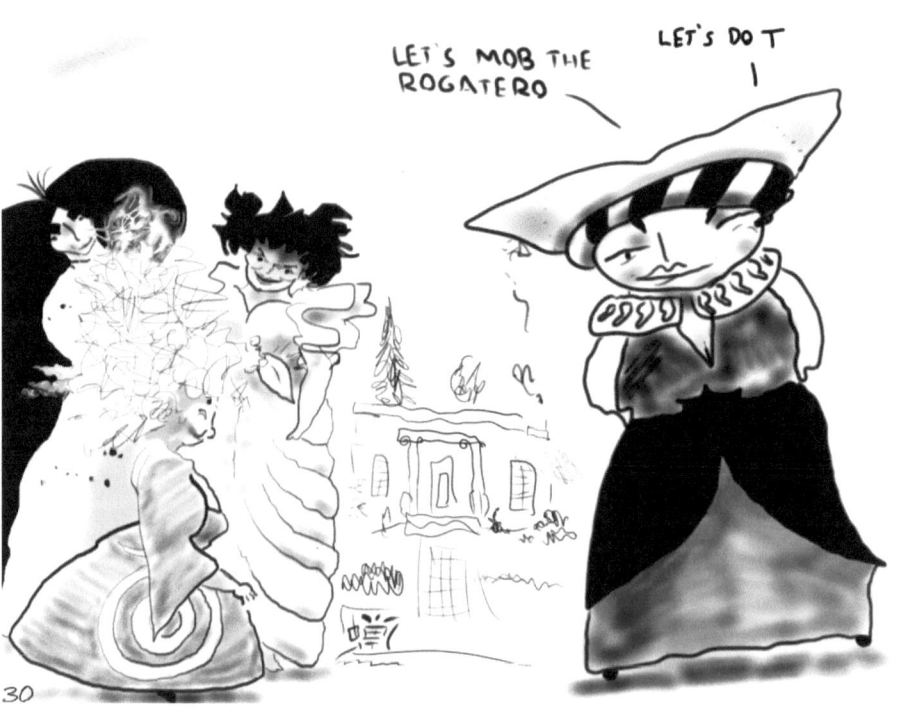

ANNIE IN THE ROSES

BIRTHDAY GIRL

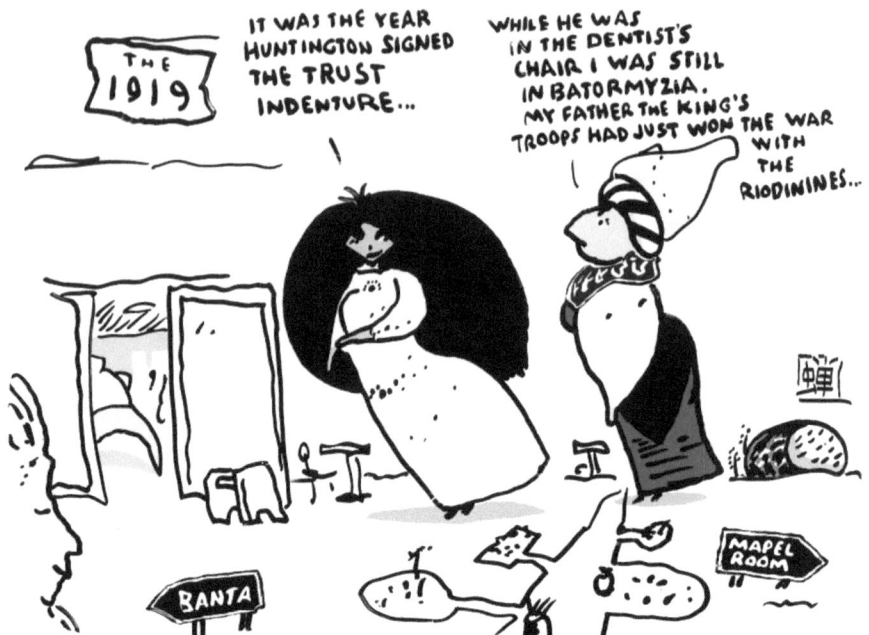

IN 1947 QUEEN SMETTIE ENTERED OUR UNIVERSE AFTER HER DEATH, AT AGE 51, IN HER NATAL UNIVERSE. HER AGE FROZE HERE, AND SHE IS STILL 51 WITH 121 CANDLES ON HER LAST BIRTHDAY CAKE. HEIRESS TO HER VAST KINGDOM BUT A VICTIM OF FOUL PLAY, SHE BROUGHT ENOUGH TREASURE WITH HER TO BE THE WEALTHIEST WOMAN IN OUR WORLD. THE MOST PRECIOUS OF THAT TREASURE IS THE GOLD IN HER HEART. HER TWO BOSOM FRIENDS, SUNSPOTTED MONIKKA AND THE SPIRAL GEISHA NAMIKO, HELP SMETTIE TO ESTABLISH HER LOST EMPIRE OF KINDNESS AT THE HUNTINGTON.

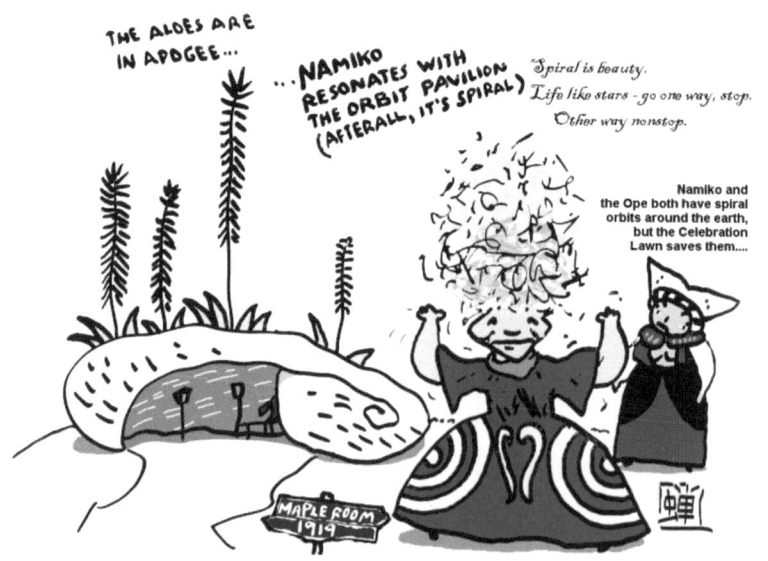

THE QUEEN ON RETICULATA KNOLL PICKS ONLY THE FINEST LEAVES FOR HER AFTERNOON TEA

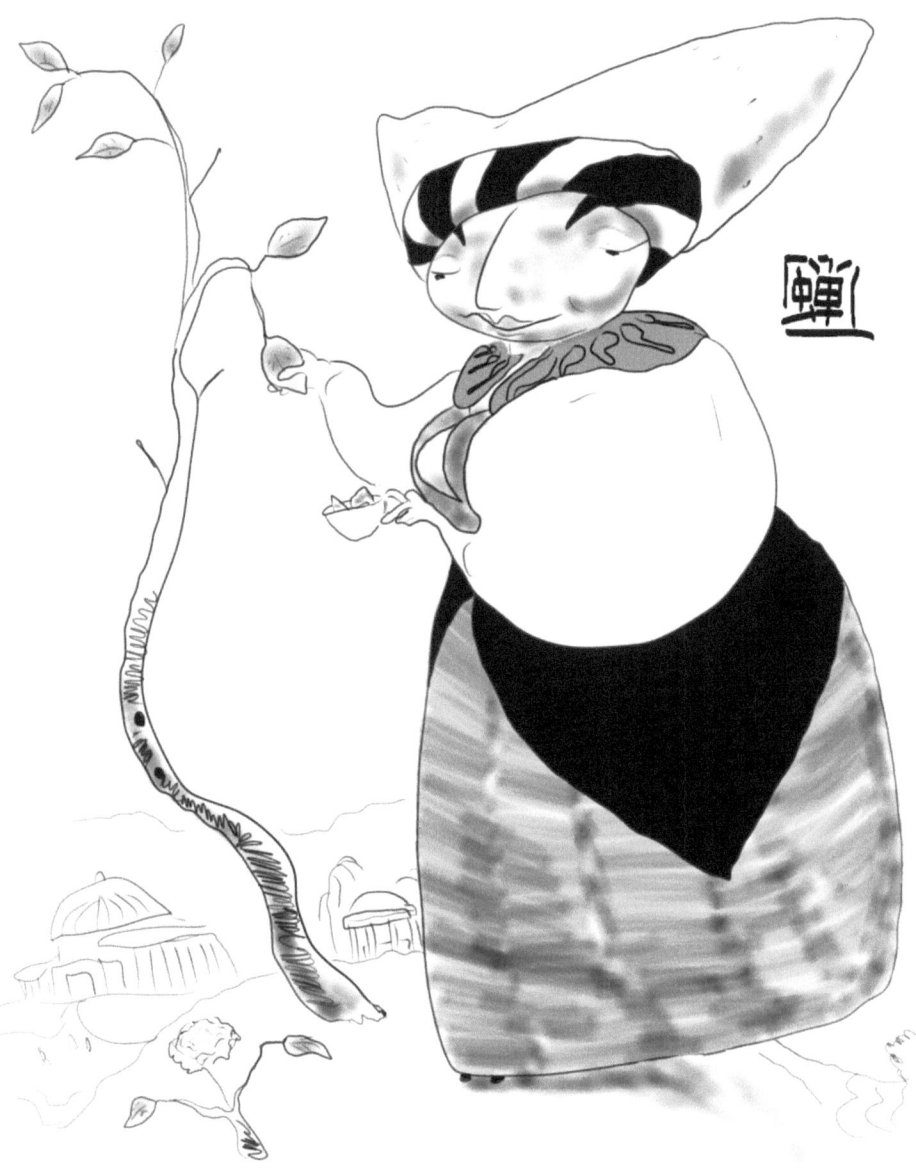

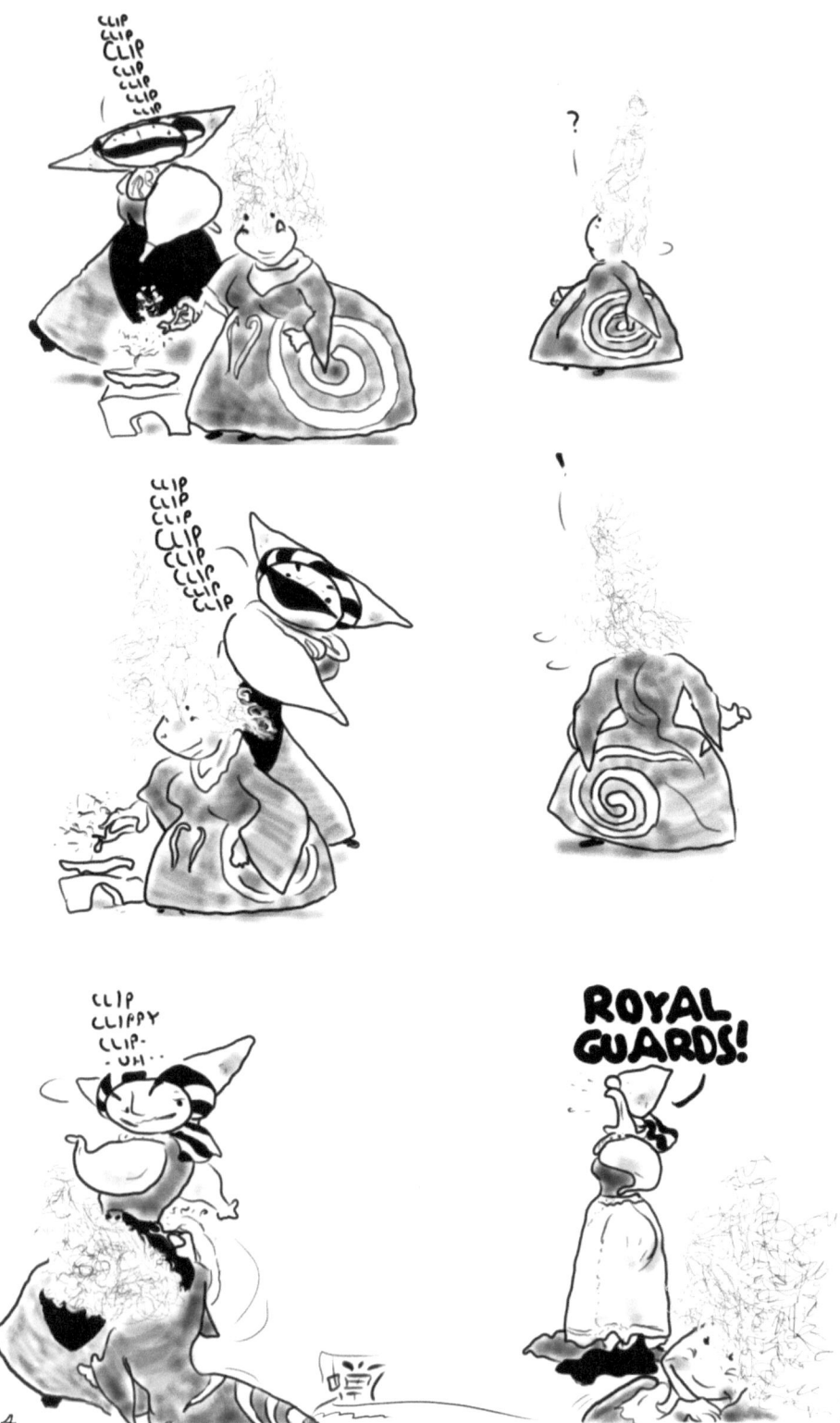

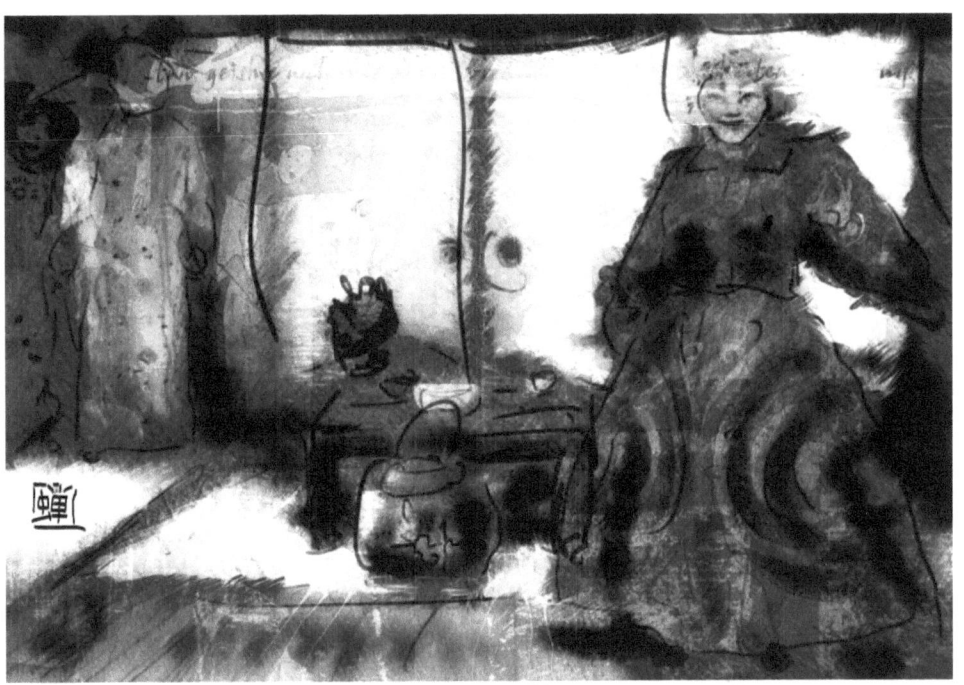

THE HUNTINGTON ON YOUR LUNCH HOUR?

CEREMONIAL TEA GOTTA BOIL VERY FASTLY IN THE MICROWAVE. SERVE WITH GLAZED DONUT. IF YOU DON'T KNOW HOW TO DRINK TEA WITH CHOPSTICK, OKAY TO USE STRAW.

YOU MEDITATE IN GRIDLOCK ON JOURNEY HOME THIS EVENING.

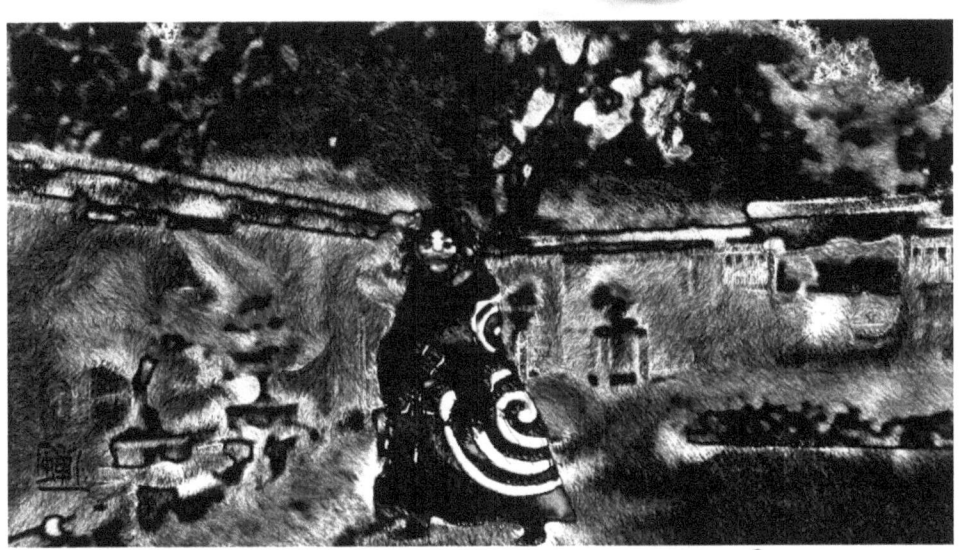

THE JAPANESE HOUSE, 1912 (TOP) THE BONSAI COURT, 1968 (BOTTOM)
(THAT'S WHEN THEY WERE BUILT... NOT WHEN I PHOTOGRAPHED THEM!)

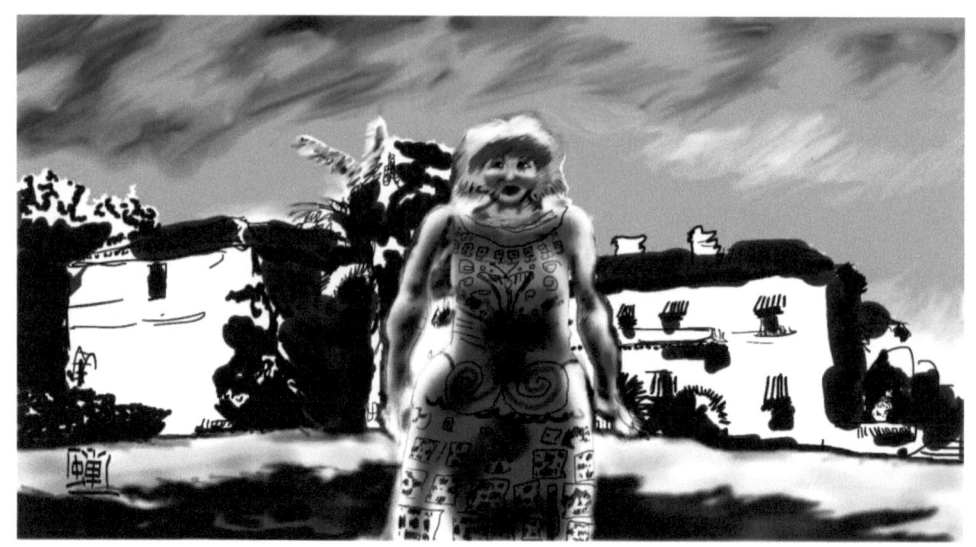

HOT SUMMER'S DAY. LOREEN APPRECIATED THE PRETEND SHADE I GAVE HER. THERE'S ACTUALLY NOTHING BETWEEN THE MANSION AND THE TEMPIETTO.

ART AND FINERIES... SURE... BUT TIRED LITTLE GRANDKIDS ARE MY LIFE WHILE MOMMY AND DADDY ARE OFF FATTENING THEIR CAMERAS.

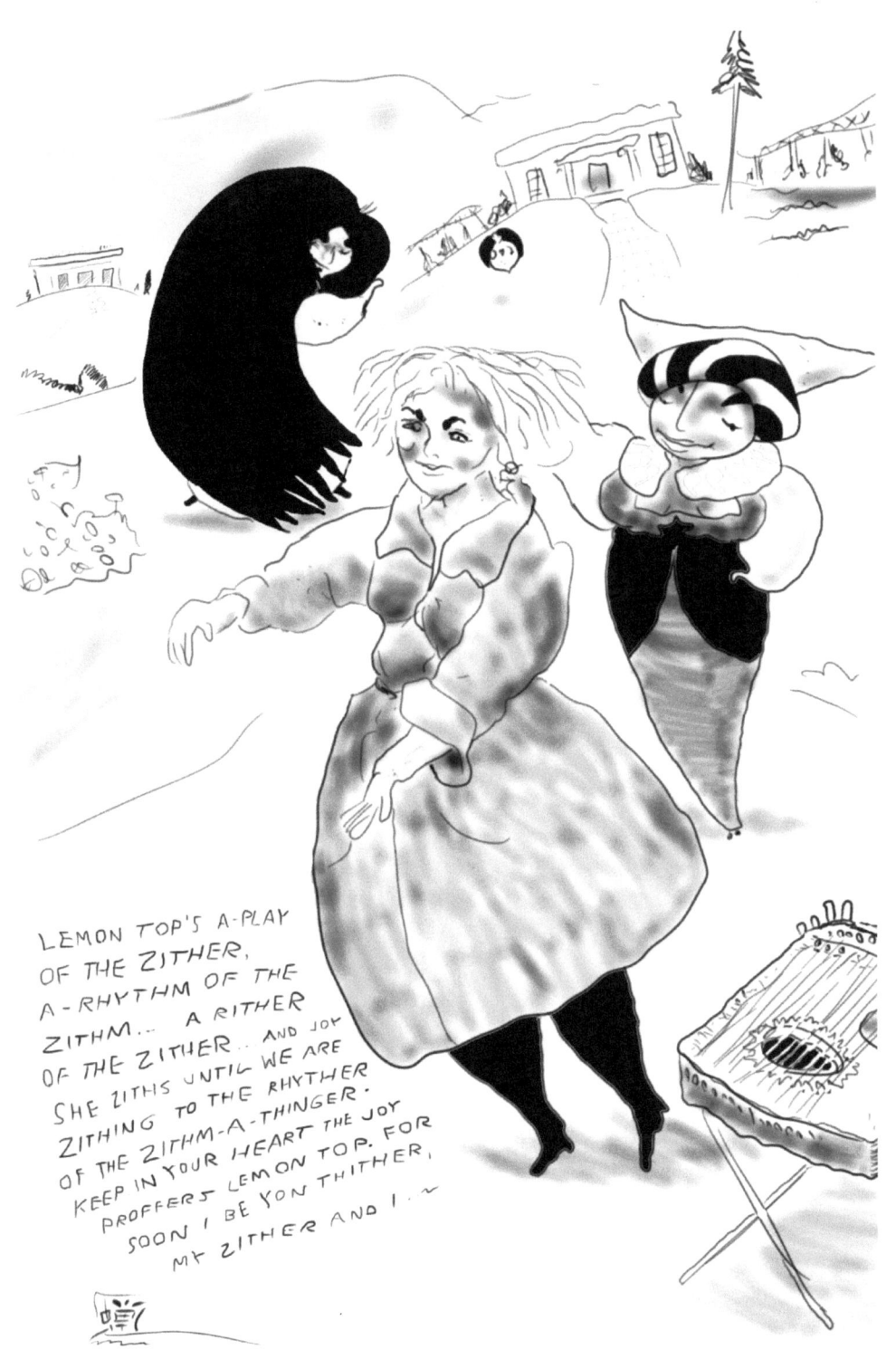

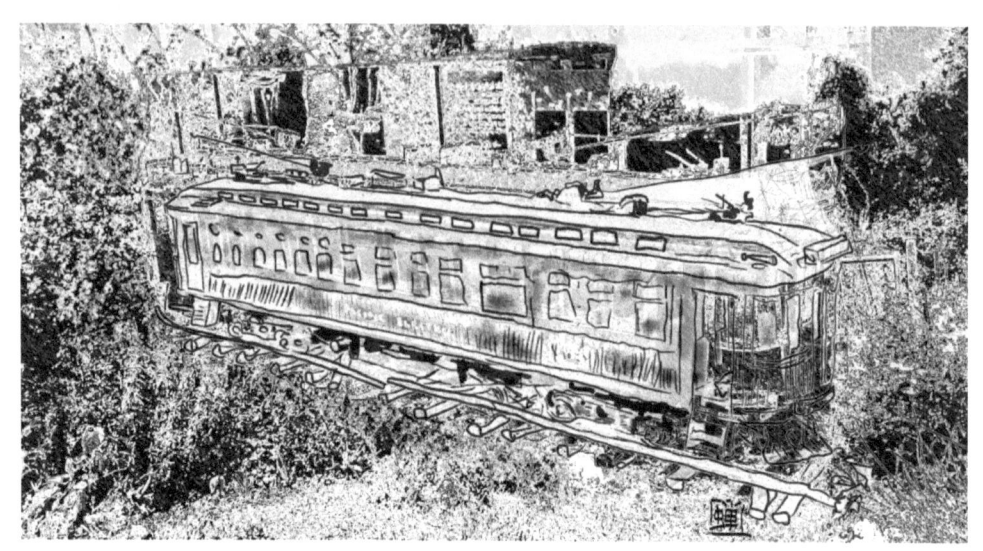

This old faded red thing has no place in a museum. It belongs out on the track where it never wasn't needed.

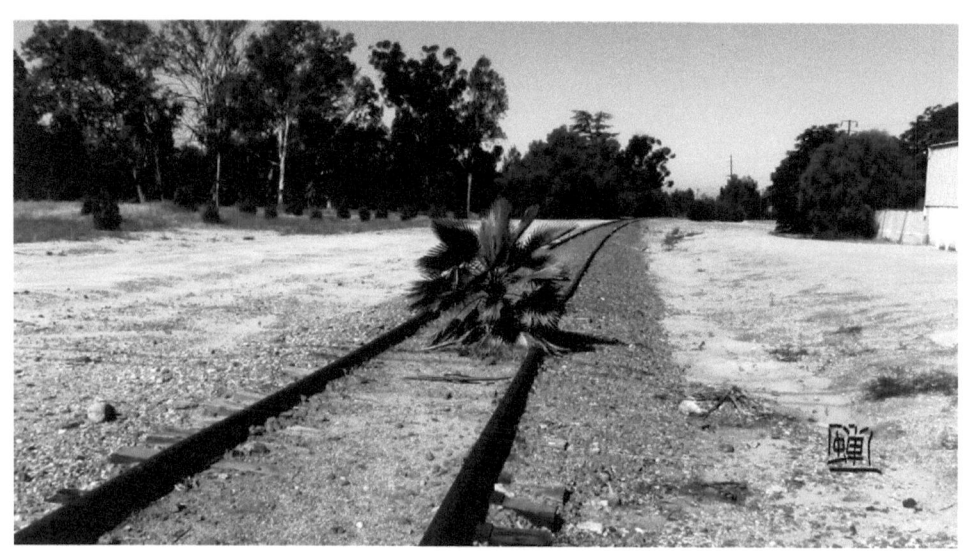

Huntington's legacy

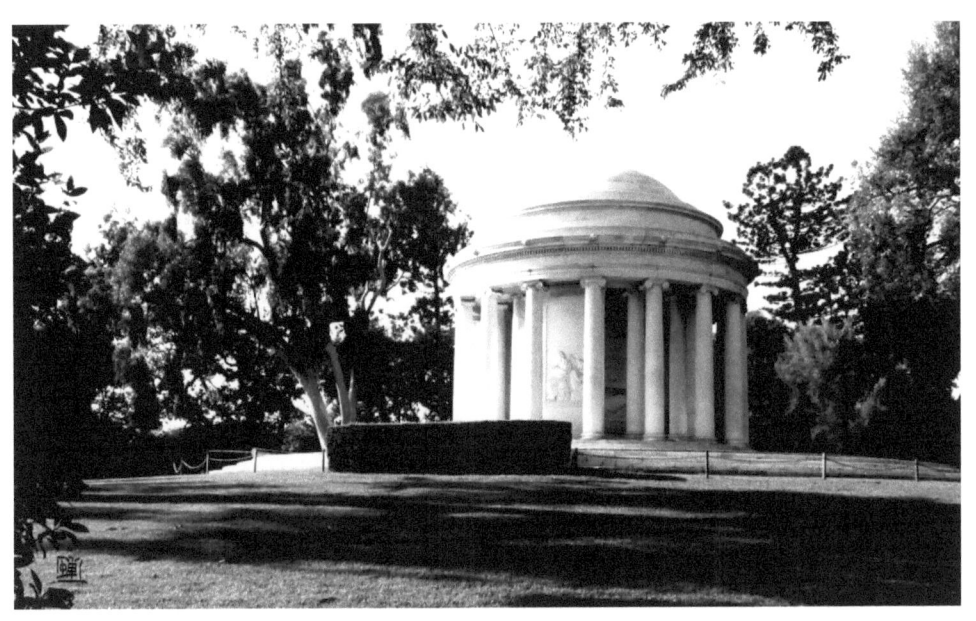

Arabella chose the spot....

Time has never honored
a nation or an economy.
Only the spirit has been the
preservation of humankind.

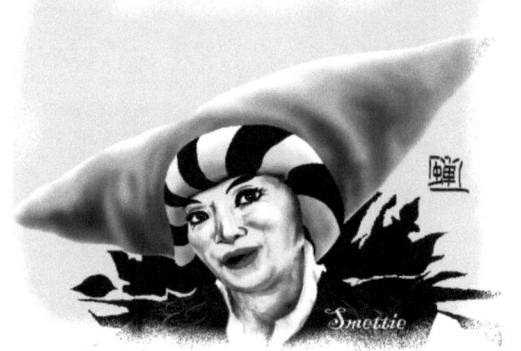

THE ART

Page 5 ***Luo River Goddess in Liu Fang Yuan***
HPG 1_1 nee AH_20_9, altered photograph with freehand painted figure, 2016 (seed)

This completely freehand, unmodeled painting was inspired by very scant mention in Huntington literature of a poetic rhapsody by the third-century Chinese poet Cao Zhi in which he coined the phrase *liu fang* – "flowing fragrance". The Huntington chose these words for the formal name of its new Chinese garden. Though I didn't invent the legendary figure, her raiment is totally a product of my artistic imagination, or hayseedery, being that the local library and Jo-Ann's store had no model patterns for ancient dynastic duds. Her evocative and benevolent expression was the focus of the piece.

Page 6 ***Cartoon - In the Love for the Lotus Pavilion***
HPG 48_1 nee cart Spen 170111 Ibex 1, drawing in app, 2017

Page 7 ***Jade Ribbon Bridge in winter***
HPG 5_1_1, altered photograph, 2016 (seed)

The loti have shed their big floppy flowers and long turned to wooden shower heads, the wisteria is all gone to beans, maple and ginkgo have banked their flame, and it's up to the storied camellias along North Vista to bring midwinter hordes to The Huntington. There's no shortage of flowers in this winter wonderland. Roses are left up until after the nearby tournament on New Year's Day; a cavalcade of camellias is in place to relieve them in January. Neon aloes blaze amongst columns of cactus along desert garden trails. In midwinter plums bring soft white and pink snowfall to the Japanese and Chinese gardens. And, if it's cold and rainy, there is always a show of orchids and other tropicals on offer under cover in the equatorial warmth of the conservatory.

Here, on a gloomy January day, the Jade Ribbon Bridge hibernates in solitude, yet ever lord of a cold, mirror-still lake. Visitors...over on the other side of the property ogling all those things above...have forsaken Liu Fang Yuan, adding to a bleak emptiness. The Chinese scholar is left in peace to meditate on the spheres, or the photographer his panoply of camera settings, the heron its empty stomach a-wait of fish. Billions of buds herald coming spring, whose alarm clock is already awakening them to the imminent burst of leaf and bloom. Oh, yes...life, crowds will again flourish.

Page 8, top ***Cartoon - Luo River Goddess and H. E. Huntington***
cart 170529 1_1 nee cart ktx 6, drawing in app, 2017

Huntington himself did not envision a Chinese garden and had nothing to do directly with the establishment of Liu Fang Yuan which came along nearly a century after his death. I am confident, however, that were he to return and express his customary foresight, H. E. would surely be duly proud of the inspirational momentum of The Huntington in our time. The garden was indeed laid out around an unused slough area that provided ready-made terrain for the scholar's garden lake.

Page 8, bottom ***Pavilion for Washing Away Thoughts***
HPG 3_1_1, altered photograph with freehand painted figures, 2016 (seed)

Page 9 *Midsummer Lotus Bloom in Bi Zhao Tang*
 HPG 2_1_1, photograph with freehand painted figures, 2016

 Big floppy white and pink flowers and showerhead seed capsules grace this bed of Sacred Lotus near the Love for the Lotus Pavilion in The Huntington's Chinese garden Liu Fang Yuan.

The Indian or Sacred Lotus *Nelumbo nucifera*, native to Asia, is one of the world's few warm-blooded plants, able to maintain a human level of body heat within its flowers even on chilly days. Presumably it's to aid pollination by creating little heat magnets that attract insects, and the dispersal of scent to get these on the run. The giant Corpse Flower, an aroid, does likewise and North American Skunk Cabbage, also an aroid, is similarly hot headed which enables it to begin emerging in late winter by melting its way up through the snow.

The common impression that loti are a type of water lily yields to molecular evidence which suggests they are more closely related to sycamore trees and to the proteas of South Africa. No holds barred for convergent evolution!

All parts of the Sacred Lotus are edible, and it is widely used in Indian and Southeast Asian cooking. Apparently the greatest risk in consuming uncooked lotus is of ingesting nasty parasites that live in the water it grows in.

Yellow blossomed *Nelumbo lutea*, the only other species in the genus, grows in the eastern US, Mexico and the Caribbean. It occurs as far north as Minnesota, where it would REALLY need its body heat. Actually, I don't know if *lutea* is warm-blooded like its tropical cousin.

Page 10, top *Cartoon - The Pavilion of the Three Friends*
 cart spb 170511 1_3, drawing in app, 2017

Page 10, bottom *Winter Blossom*
 HPG 6_1_1, original art with altered photograph, 2016 (seed)

 The story of the three friends intrigued me because upon my first visit to Liu Fang Yuan I was writing a story about three friends. In Chinese lore the three friends epitomized loyalty in duress. In winter there it must take courage and unity to hang onto one's strong nuclear force, but in friends is warmth worthy of courage. The metaphor is in plants: Pine for endurance, because it remains green throughout winter, bamboo for flexibility…it bends to the cryogenic winds…and flowering plum for the soft white and pink snow of its flowers breaking frost for soon spring.

Valentine smoochers and puppy-lovers strolling lakeside are invited to the scholar's wisdom. This round little bokky, a divine caritas icon from a sci-fi multiverse fantasy, holds within her belly a view of the pavilion comprising all worldly abandon; a wanton waste whose void magnifies friendship lost yet ever there. "Fill me up," she says. "Because I am empty but if you fill me likewise will you always be."

The text I wrote soon after creating the bokkies reads: "Nothing's more valuable than a friend. Treasure yours. Be gracious for the one who gave you life and the one who joins your walk in life. Train your own walk so you won't stumble in the first place. If your

heart is round you'll roll…you won't gather moss and regrets. Be creative. Gather not unto yourself but give gifts. It's a lot happier. Planting little seeds of joy isn't a small sort of thing; it's life's way. Live that way, and nothing can extinguish you. Life isn't yours; it was loaned you by your friends."

Page 11	***Cartoon - Chinese viewing stone at Ying Fang Hu*** HPG 38_1 nee cart DEB x 3 161222 ren, drawing on dry-erase board, 2016
Page 12, top	***Cartoon - The Year of the Rooster and the Ope*** art 14_2 from cart Spen 170107 SB 5, drawing in app, 2017 (seed)

NASA/JPL's edutainment exhibit the Orbit Pavilion docked at The Huntington in late 2016, and the rooster raucously ushered in his year of proud, determined confidence as Liu Fang Yuan decked out for the celebration of Chinese Lunar New Year the following February. Pages 12-15 include some of my sketches of the Chinese observances.

The Orbit Pavilion is basically a small outdoor auditorium made of sculptured aluminum sections that assembled form a nautilus-shaped spiral enclosure. Inside are a few benches and a set of speakers that recreate composed sound effects designed to emulate, in artistic fashion, our panoply of satellites passing in the night, and in the day, over our heads…a reminder that our gridlocked freeways are a-whoosh both on and off the concrete beyond the windows of our home and office routine. The Ope serenades 19 earth-monitoring satellites and the ISS, but only in symbolic manner since there is no actual electronic communication between any satellite and the pavilion. The soundscape is nevertheless captivating, even if it resembles digital mind-reeling of such as I with musical instrument emulator software in 3 AM mode (think frog cantata with castanets, vibraphone and bilious train whistles). Each featured satellite has its own motif in the composition. The Orbit Pavilion exhibit includes interactive computer visuals geared for school children. Temporary, the Ope egressed The Huntington in late 2017 and has presumably gone whistling Twinkle Twinkle Little Creeping Star under other skies.

(Actually, satellites don't twinkle.)

Page 12, bottom	***Cartoon - drawings of regionally costumed characters*** art 170608 1_10_1, drawing in app, 2017
Page 13, top	***Guo Jie Tai Chi in the Clear and Transcendent Pavilion*** HPG 15_2, drawing in app, 2017
Page 13, bottom	***Tai chi duo*** HPG 35_1 nee art spb 170306 1_3 CNY 17, drawing in app, 2017
Page 14, top	***Shaolin Temple Cultural Center performers*** HPG 39_1 nee art spb 170310 1_2, drawing in app, 2017
Page 14, bottom	***Ceremonial mask-changer in performance*** HPG 44_3_1, drawing in app, 2017
Page 15, top	***Soloist, music of China in the Plantain Court*** HPG 36_1 nee art 170301 Spsb 1_3, drawing in app, 2017

Page 15, bottom ***Hava bongoing in the Love for the Lotus Pavilion***
HPG 28_1 nee HAV 1_3_1, photograph with freehand painted figure, 2016 (seed)

What! Mardi Gras at The Huntington? Close in time of year, at least, inebriated revelers clamor on Bourbon Street amidst showers of throws and s-krewe-y pageantry while half a globe away they are mirrored by dragon mimes awash in showers of fireworks. After all, The Huntington is practically closer to China than to Cajun bayous, but a spirited Cuban star might not shy an appearance in the Love for the Lotus Pavilion. Here is Hava of Havana, who proffers that no part of the world has an antidote for Cuban rhythm. When the cat and his Chinese zither are away, the mice salsa. But, don't worry, The Huntington's little table is safe. Hava is a celebrity who's happy, friendly, outgoing, charitable and genuine of character, therefore she's fictional.

Page 16 ***Cartoon - Bumble bee in foxglove***
HPG 51_2, drawing in app, 2017

Page 17 ***Amorphophallus titanum, "Stinky # 5", in curtsey***
HPG 7_2, photograph with freehand painted figure, 2015 (seed)

Many are they who come to The Huntington to appreciate a colorful bouquet that's on offer somewhere in the various theme gardens at any time of year. Then there are those of us who blaze trails there precisely to behold flowers that stink and aren't pink.

In 1999 The Huntington hosted California's first and the US's eleventh recorded blooming of a cultivated oddity from tropical Asia…*Amorphophallus titanum*, the Corpse Flower. As of 2014, The Huntington was up to bloom number five in its own collection of these plants. Blooming is rare and usually makes the headlines wherever they pop out. It's a posy of superlatives. An aroid, *titanum* produces but one leaf at a time, a monstrous parasol-shaped affair divided into three top branches with many side leaflets that make it resemble a tree fern, stemming from a ridiculously small corm (tuber) no bigger than a supermarket pumpkin. The leaf may last one, two, three years before dying and being replaced by another leaf. There may be many leaves in succession before the plant is fat enough to put up its giant flower.

This flower is the grand arpeggio. It is the largest known compound flower and can be as tall as a person. It is a member of a large worldwide group of less-recognized flowers of many families that have exploited an underused niche; instead of the sweet aromatics we normally associate with flowers they produce nauseatingly fetid odors that bring in flies and other insects not normally employed as pollinators. Most such insects are attracted not by nectar that promises a power drink, but by the odor of unsavory egg-laying sites. In the case of the Corpse Flower, research has apparently revealed that tropical sweat bees largely do the honors. My guess is that these bees are actually after a smorgasbord of amino acids and salts found in decaying animal matter. These supplements help the bees (and many other insects) produce grade-AA eggs.

The goofy Corpse Flowers seem doomed to their own poor design, as it were, for survival. Even in their natural habitat, unfortunately highly impacted by human activity, they bloom infrequently, tend to be far apart, and are receptive for such a short time that it would appear beyond reasonable probability for the little bugs, of limited flight range, to facilitate a viable exchange of pollen. Fortunately, *titanum* is easy to grow under

controlled conditions and now the pollen express is being aided by human researchers with sophisticated tools like kids' paintbrushes and FedEx for the benefit of its ex-*situ* preservation.

Queen Smettie provides visual scale for the Corpse Flower's immense size. Its pleated spathe actually encloses numerous individual florets of both sexes arrayed in corncob fashion around the bottom of a baguette-like stink stack. Unrelated *Rafflesia*, itself a stinker, is the largest known single flower, and the Talipot Palm is grand winner for an inflorescence. All three of these champions are threatened in their equatorial natural habitats.

The Corpse Flower announces its perilously brief climax a month in advance, but it is difficult to aim for the window which is usually only a few hours one night. By time I could scramble to make the hour's drive to The Huntington, the show was over. Fictional Queen Smettie had only my photos of a wilted aftermath to show off. The Huntington's botanical specialists had successfully hand-pollinated Stinky # 5 just before Smettie lent her hand for the Kodak moment.

Page 18, top **Cartoon - Impatient Monikka goads Amy**
MON 170611 1_1, drawing in app, 2017

Page 18, bottom **Cartoon - The Huntington's centennial challenge**
cart ktx 5, drawing in app, 2016

I would challenge The Huntington on this one: What more honor in the botanical West than to be the first to cultivate a Giant Rafflesia? This champion of flowering plants with the world's largest single flower able to reach forty inches or more in diameter, *Rafflesia arnoldii* and its sibling species are endangered in their native habitat as the rainforests of Sumatra and Borneo are being relentlessly ravaged. The co-occurring Corpse Flower, *Amorphophallus titanum*, is more fortunate if only because it has proven relatively easy to cultivate artificially.

The challenge is that Giant Rafflesia is a parasite. It needs a specific host, a woody vine in the grape family, within which to grow. So The Huntington has to get these vines going and find some husky grape stompesses from Tuscany to put seeds on the bark and dance on top of them to inoculate the foster parent. The Rafflesia then grows like a mycelial fungus inside its vine host and, after several years, puts out its only visible part, that outlandish flower, whose bud pops out of the vine and for almost another year expands to the size of a basketball. This is usually near the vine's roots so that Rafflesias are typically found on the ground.

Once open, the flower lasts only a week or so and emits a fetid stink similar to the Corpse Flower, drawing in whatever necrophilous insects or other small creatures pollinate it. Nobody knows for sure just how pollination occurs or how the seeds get dispersed. If The Huntington is meet to the challenge for this stinker (and The Huntington's *A. titanum* plants don't mind), there may be a proposition for everything from lively Italian girls to a new conservatory for grapevines, maybe even a winery, and world recognition for a botanical breakthrough. Docent Monikka is adventurous enough, but Queen Smettie, accustomed to stalemates, is being a bit downwind.

Page 19, top ***Hey, Ma! Where's the beef?***
HPG 8_1_1 from Vixtill 15003_10_2 101115, photograph, 2015

Like many of the world's lesser admired but more fascinating florals Starfish Flowers, or stapeliads, are often stinkers, roping in flies for pollination in favor of busier bees. Flies are attracted not so much for food and drink, but to lay eggs. Many Starfish Flowers closely mimic the odor of dead animals, and even their appearance.

Fooled female flies fling their eggs on the flowers, but all the flower cares is that a fly snags some of its pollen and packs it off to an eligible *Stapelia* of like species down the lane. While this Valentine postal service is under way, the eggs hatch into tiny maggots with nothing to eat. These wander about aimlessly in a group bawling for Ma in their larverly way; they can be seen as white smudges near the center of the left flower. If stapeliad flowers were more numerous than the deceased animals they imitate, it would be bad for fly species because most larvae would starve and their niche would collapse. But evolution is a self-regulating system, which ensures that won't happen. If stapeliads died like flies for not being pollinated, they soon would fall below the animal vital statistics.

Starfish Flowers are in the dogbane family Apocynaceae, which includes milkweed. Their foliage often resembles cactus, but there is no close relationship. The grand specimens in my photo are probably *S. gigantea*; these dinner-plate sized flowers were saffron yellow with a beautiful reticulated pattern of fine blood-red lines, all combed in silky little hairs. The petals are rather thin and tend to curl back at the edges giving an impression of puffy thickness. The giant buds resemble Chinese lanterns before peeling back their five petals in summer and fall. For those who nose a bit beyond the standard posy pretties (and don't mind occasionally unfloral essences), stapeliads offer an introduction to a treasure trove of natural wonders beneath...uh, right under...our noses.

Page 19, bottom ***Comet Orchid in Rose Hills Foundation Conservatory***
HPG 22_2_1 from Nik 161228 Hunt 3, photograph, 2016

Oh where oh where has my little moth gone?...

This beautiful Comet, or Darwin's, Orchid in the conservatory has no big-mouth moth to pollinate it. Darwin's Orchid (*Angraecum sesquipedale*) is from Eastern Madagascar where it grows on exposed tree trunks at forest edges. There it blooms from June through August but in cultivation far from its native home, including The Huntington, it pops out around Christmastime, earning one of its common names "Christmas Orchid". And indeed it is a magnificent flower worthy of high holiday calling. Not immediately evident behind its waxy white Star-of-Bethlehem crown is a ridiculously long spur, up to seventeen inches in length, hiding a spot of nectar that can be got at only by one very-long-tongued insect. (The Latin *sesquipedale* means "one and a half feet long".)

About half of the spur, resembling a lamp cord, appears below the flower. The spurs of flowers above the view are seen on either side.

Darwin put his logic to the task and figured that there was an insect co-evolver whose tongue would fit that long green soda straw. He was right; the insect, a species of sphinx moth, was later discovered by another scientist who named it in honor of Darwin's prediction. For some reason, the nocturnally scented orchid left the more usual bees and

beetles to fight for other nectar bars and took on this moth as its partner. Over eons of time it is likely that moth and orchid jockeyed evolutionarily to get the length just right, because the pollination mechanism requires an exact fit in order to work. They finally got it after both moth and orchid had grown to excessive dimensions in their respective equipment. The moth, about the size of a hummingbird, has a coiled "tongue", or proboscis, which extends more than a foot, far longer than that of any other insect its size. An alternative theory invokes hunting spiders which are able to jump on a moth close by; a long proboscis would enable the moth to slurp from a safer distance but at which it could not pick up the orchid's pollinia. Orchid's answer? Put the nectar out of reach to force the moth closer.

Page 20	**Winter in the Shakespeare Garden** HPG 9_2_1, drawing in app, 2017	
Page 21, top	**What does The Huntington mean to you?** HPG 49_1, altered photograph with freehand art, 2016 (seed)	
Page 21, bottom	**Namiko the butterfly collector** HPG 40_1 nee art 15016_1 old 14006, drawing in app, 2015 (seed)	
Page 22, top	**Midsummer Night's Spent - Shakespeare Garden in Fall** HPG 19_2, altered photograph, 2015 (seed)	
Page 22, bottom	**Cartoon - Diana ran away** HPG 56_1_1, drawing in app, 2017	
Page 23	**The Virginia Steel Foundry** HPG 54_3_3 from Vixtill 15003_17 101115 (Oct. 11), photograph, 2015	

 Uh...make that The Virginia Steele Scott Galleries, The Huntington's offering of American art from colonial times to the middle of last century (there's somebody named Erburu in there too, and a certain Chandler, but I can't keep up with The Huntington's penchant for honorees...ask a docent if you can find one who knows). It's a treasure trove of American visual witness pretty much across the spectrum, and will give any art historian an excuse to spend many rainy days attending to passions besides flowers.

I don't bother with those fancy-schmancy tourist-shooters that take automatic panoramic photos, so I had to get out chisel and sculpt this one by hand to restore perpendicularity to the strongly architectural subject, at the cost of some mushiness. Be not Ansel or Weston I, but the value of vertical juxtapositions such as the trash container (which would normally beg to be excised) and the repetition of curved forms in the dome and the boughs above were not to be passed over. Look closely and you'll see Diana, a life-sized bronze by Archer Huntington's second wife Anna Hyatt, in the loggia, bow raised skyward and arrow off to snag a hapless sparrow for her supper. The building on the left (east) houses art collection staff offices not open to the public.

Steel foundry? Nearby on the grounds are three massive blast furnaces that now roast the camellia leaves picked every day in North Canyon and on the North Vista which are used for next day's high tea in the Rogatero. The roar of those blast furnaces can be heard through the night across the San Gabriel Valley. Now, if you believe that, you'll believe

my story about Route 66 crossing the Pacific, emerging at Shanghai and continuing west through the silk route and Europe, the Pond, eastern North America and back into Chicago.

Page 24, top **East Loggia**
HPG 18_2_1, altered photograph, probably 2015 (seed)

Page 24, bottom **H. E. and Arabella meet for dinner**
HPG 45_1 nee art DNR Feb 2017 Spsb 1_10, drawing in app, 2017

Page 25 **Cartoon - Namiko spoofing Pinkie in the Thornton**
HPG 31_1_1, drawing in app, 2017

Little bighearted Namiko enjoys one-upping everything with mirth. Skills and wit learned in her younger geisha years spice her popularity as an instructor of bonsai and ikebana. But unlike fictional Namiko, Pinkie is a real story.

Pinkie the Pop Icon (the better half of The Huntington's two most famous) undoubtedly graces many genteel parlors near and far wherein there is little knowledge of the real person behind the egg white. Sarah Goodin Barrett Moulton, affectionately nicknamed Pinkie, was painted, at age only eleven, in 1794 by Thomas Lawrence. The Barrett family were wealthy landowners, slave owners and sugarcane and rum exporters in the Jamaican Colonies, and Sarah was born there in 1783. Her father Moulton, however, abandoned the family when Sarah was six; three years later the child took passage to Britain to attend school. The following year Sarah's grandmother in Jamaica was missing her granddaughter so badly she commissioned the artist Lawrence to paint her. I have yet to figure out how, in the days before Facebook or even the comparatively slow Concorde, that lady was able within the space of just a year or so to arrange a commission in such timely manner as to have the sittings done within Sarah's tragically truncated lifetime. But there it was, the showcase of the east end of the Thornton Portrait Gallery, on its way in 1794 to delight, I'm sure, the tearful eyes of her who would never again see her beloved grandchild alive.

I have found no mention of the cause of Sarah's death. Seafaring colonial yesteryears were rife with calculated risks of malady that medicine had yet to conquer; Sarah's legendary sister-in-kind Pocahontas, some 180 years her senior, suffered a like fate, and lies buried at Gravesend. Sarah likely had great youthful potential, and the painting has been interpreted as showing her demonstrating the poise (perhaps in a dance step) of British aristocracy. One may only speculate Sarah's impact on her times had she lived, and the provenance of the painting that perhaps, or not, had served its family and ended up under Huntington's eye at an art sale. How farsighted of H. E. to bring this talented gift and its poignant story to our shores to enrich the many thousands who have seen, revered, and maybe even offered a tear for the picked rose.

Pinkie and *The Blue Boy* have inarguably been iconized, drawn hordes to The Huntington and, yes, even cruised Sunset Boulevard behind their Angelino shades. But their emergent popularity, heads and shoulders above The Huntington's other Grand Manner portraits of equal technique, still is a puzzling enigma to me.

Page 26, top **Overflow seating for 1919 Cafe**
HPG 24_1_1, photograph, 2016

If you're picky about seating comfort, aim for 1919 Cafe on less crowded days before noon. And, when they're not all covered up by squirming diners, you can better enjoy this magnificent collection of barrel cacti and similar artfully chosen desert pricklies from the comfort of a shady bench near the middle of the Desert Garden. It would appear that barrel cacti are wannabe sunflowers. In fine southwestern fashion, they nod to the sun. But, their being far less limber than a sunflower, it must for the cacti be an accent acquired only in long life.

Does *Echinocactus grusonii* tip southwards to increase photosynthesis? It seems unlikely, since their shape would confer no particular advantage to such orientation, and in addition each cactus wears a skullcap of matted feltlike white fibers (the cephalium) which prevents sunburning the scalp. The cephalium also provides a protected nest for buds and blooms. Photosynthesis occurs within the green ribs down the sides, though only above the waist because the bottom of the barrel is in the shade. It would seem that evolution thus favors *Echinocactus*'s orientation as merely a balance between a necessary level of photosynthesis and temperature control, rather like a lady pointing her parasol toward the sun to stay cool while managing her tan. But I'm not an echinogenius, so I don't have the definitive answer.

Page 26, bottom **Off the Carrier Deck**
HPG 25_1_1, photograph, 2014 (seed)

This Gulf Fritillary Longwing basking momentarily on an aloe in the Desert Garden is one of The Huntington's commonest butterflies, usually seen on the wing from spring through late fall. These bright orange flutterers are often confused with more familiar Monarchs, but the two are not closely related. Monarchs are larger and have more black on their wings. Perhaps the easiest way to tell them apart is by their larval foodplants – milkweed for the Monarchs and Passion Flower ("Maypop") for the Longwings. Wherever these two plants are seen on the grounds, there also, in warm weather, will likely be butterflies to be enjoyed. Neither butterfly frequents the other's foodplant, making it an easy way to identify them.

Gulf Fritillaries, occurring across much of the southern half of the US, do not belong to the similarly colored true Fritillaries but are more closely related to a large group of tropical butterflies called Longwings ranging from the gulf states south to equatorial regions. This one took off the instant I snapped the shutter on that warm August afternoon. The angle and shade made it hard to determine if indeed the butterfly was just an inch off the deck.

All the king's third-grade textbooks have taught us that insects have six legs. Why, then, is this butterfly missing two shoelaces? It turns out that one of the largest families of butterflies worldwide has its front pair of six legs reduced to tiny brushes which are not used for standing or walking. The Longwings are among these. Perhaps we are witnessing a geological still-frame of insects evolving into horses. More likely that the "brush-footed butterflies" have developed natty groomers for their mustaches. The underwhelming truth: Nobody knows why.

Gulf Fritillary Longwing was the beautifully photographed "poster butterfly" on The Huntington's 2017 map brochure.

Page 27 ***Cartoon - Queen wrapped up in the Desert Conservatory***
HPG 46_1 nee cart 170210 Spsb 1, drawing in app, 2017

Watch out for those bizarre plants from darkest Africa – they reach out and grab things! Okay, maybe not quite so Tarzanish, but no less fascinating. If you swing by The Huntington on a Saturday morning and visit the Desert Conservatory, at the north end of the Desert Garden just below 1919 Cafe, you can see one of the strangest plants in the entire world. A denizen of the rainless sands of Namibia and Angola, *Welwitschia mirabilis* defies description. It may outlive your dandelion by a thousand years, yet in its lifetime produces only two leaves. The leaves may be several feet wide and split lengthwise like ribbon; they grow continuously out each side of the trunk and are never shed and replaced like those of most plants. *Welwitschia* leaves grow as fast as they die at their ends, forming strap-like affairs that lay curled with tattered ends on the sun-scorched sand like some unearthly Medusa dispossessed from the waves. The two leaves are quite thick and stiff, with the texture of floor linoleum. The trunk grows no higher than a foot or so and resembles a wooden carving of a *Tridacna* clam.

Like other diehards, both animal and plant, of the Namib Desert, *Welwitschia* survives on remarkably scant moisture. Perhaps the corklike center of the trunk absorbs dew brought in by the nearby ocean, being that most creatures of the Namib survive on little more in this Mediterranean type climate-on-steroids. *Welwitschia* is a conifer, related to the much more familiar, and conventional if less efficient, pines of boreal climes. It has no flowers but cones; the female cones are prettily shaped resembling old-fashioned Christmas tree light bulbs.

Page 28, top ***The Ombu Tree***
HPG 33_1_1, drawing in app, 2017

Ombu, *Phytolacca dioica*, is one of The Huntington's showcase specimen trees, planted here as a seed in 1914. Native to the Argentine pampas of gaucho fame, it is unusual for its grossly distended lower trunk, like some colossal half-buried potato, from which thick limbs arise. It was long thought that this was an adaptation for water storage in the Ombu's dry native habitat, but evidence now seems to favor its role as a support structure. The rest of the *Phytolacca* genus comprises small shrubs and weeds more at home in pastures, including Pokeweed of the eastern US. Not trees, they produce no true wood. It seems that Ombu somehow got too big for its bombachas and needed a way to support its massive branches, so the lower trunk swelled with spongey pseudowood which, coincidentally, holds much water. *Phytolacca* belongs to the same large botanical order as cacti, carnations, beets, amarinth, and some of the carnivorous bug-gulpers.

Ombu is supposedly popular with bonsai artists because its lack of true wood makes it pliable and easy to work. The Huntington's Ombu is located low on a twisty trail winding through the tropical garden, just west of the lily ponds. Its flexible foot is well-appointed because it sits astride of a local earthquake fault. Don't eat of this tree; all parts are toxic.

Page 28, bottom ***Cartoon - Monikka entering Rogatero***
MON 170620 1_1, drawing in app, 2016

Page 29, top ***Art student a-sketch in the Thornton***
HPG 42_1 nee art spb 170323 1_4_1, drawing in app, 2017

Page 29, bottom ***Tea time***
 HPG 17_2_1, drawing in app, 2016 (seed)

The Rogatero is where it's at! Jitterbug and jive? More likely chutney and chives; certainly one of the valley's most appointed watering holes for culture vultures migrating Huntingtonward. The Rose Garden and adjacent Herb Garden, and the Shakespeare Garden meandering northward, all focus on the experience of high tea in grand manner within its venerable panes. Not for diners on a budget or young children craving county fair fare...the gelato bar at the Red Car and the sandwich counter at 1919 Cafe are their privilege. It remains beyond my senses but if the Rogatero does tea as fashionably as The Huntington's other forward culinary venues, the Queen herself should be no less than complemented.

My own fictional queen Smettie and her friends are regulars here. I wish I could share in color her beautiful costume with magenta hair cones and tangerine striped scarf and her lively banter with her two bee eff evves over matters of the day from antiquity to science, spirituality, and whether anyone saw the dog at *The Blue Boy's* foot.

The Rogatero started out as Huntington's private bowling alley and billiard room. As a tea room it is perhaps a bit overcrowded with every possible square inch appointed a table; the conviviality at high hour is more akin to California Pizza Kitchen. I don't hang out at Buckingham Palace, so I don't know how it's done these days there either. But here is a ceremonial Angelino gathering. Oddly, it goes by "Rose Garden Tea Room" everywhere except on the front door, where it's "Huntington Tea Room". So where is the Rose Garden Tea Room? The Rogatero is where it's at.

Page 30, top ***Cartoon - Queen Smettie in the Rose Garden***
 HPG 37_1 nee art spb 170309 1_2, drawing in app, 2017 (seed)

Page 30, bottom ***Cartoon - The Rogatero Mavens***
 HPG 47_1 nee cart Spen 170106_1 SB, drawing in app, 2017

Page 31, top ***Annie in the Rose Garden***
 HPG 43_1 nee AGW spb 170321 1_7, drawing in app

Page 31, bottom ***Girl waiting for reservation in the Rogatero***
 HPG 16_1_1, drawing in app, 2017

Page 32, top ***Cartoon - 1919***
 cart DEB x 6 170101 ren, drawing on dry-erase board, 2017

Page 32, bottom ***Cartoon - Namiko and the Ope***
 cart DEB x 5 161231 ren, drawing on dry-erase board, 2016

Page 33 ***Cartoon - Queen Smettie on the North Vista***
 cart spb 170329 1_2, drawing in app, 2017

Page 34 ***Cartoon - Namiko clipping her bonsai***
 cart 170131 Spsb 2, drawing in app, 2017

Page 35, top ***Namiko in the Japanese House***
 HPG 13_2_1, altered photograph with freehand painted figures, 2013 (seed)

When the West "discovered" Japan in the mid-nineteenth century, a Nipponese trend took American fashion, architecture and landscaping by storm. This reached a peak in the early 1900s, when Huntington sought to establish his part and parcel in a canyon west of his retirement mansion as the latter was being readied for occupancy. Though Japanese tearooms were popular, one in nearby Pasadena had fallen on hard times. After Huntington's superintendent William Hertrich tried to wager for the botanical specimens there, Huntington bought the entire house and had it moved to the site it now occupies, along with plants. It was ensconced and landscaped up in record time, possibly because Huntington wanted it to be a wedding gift to his second wife Arabella in 1913.

The house, rather large for a typical Japanese dwelling of the time because it had served as a tearoom, now proudly offers a static display space for Japanese arts like ikebana, and anchors the entire garden which is a main attraction for strolling visitors. It seems a bit too bad The Huntington doesn't make more active use of this beautiful gift of its founder. A new ceremonial teahouse was donated in 2011 and sited in a special garden behind the main house, but it is open only infrequently for special occasions. What a wonderful location that could be an effective setting for Japanese festivals, lunar new year observances, performances and the like.

Page 35, bottom **Namiko in the bonsai court**
HPG 14_1_1, altered photograph with freehand painted figure, 2016

Page 36, top **Loreen in the shade in the Rose Garden**
HPG 11_1_1, drawing in app, 2017

Page 36, bottom **Granny minding the kids near Scott Galleries**
HPG 30_1_1, drawing in app, 2017

Page 37 **Cartoon - Lemon Top playing the zither**
LMT 4_5, drawing in app, 2017

Lemon Top's a performing street artist who makes her home in the once-neighborhoods of H. E.'s uncle Collis. Though a bit out of place in Angelino territory, she resonates with The Huntington, her lively zither strains providing today's incentive for a BFF dance between Monikka and The Queen. In color Lemon Top has a knock-your-socks-off laser red coat and shocking saffron hair. But she's a fast gal – nobody at The Huntington could catch her. So I can offer only this sketch from my memory. (An elegant way of admitting that she is fictional.)

Page 38, top **What did I not give you?**
art 170628 1_4, altered photographs with freehand drawing in app, 2017

Page 38, bottom **End of the line**
art 170629 2_2, photograph, 2016

Two of H. E. Huntington's favorite things, railroads and palm trees, emblemize in this scene a bitter end-of-the-line on the farthest outreach of an empire ruthlessly parasitized by the march of his century. The picture was taken near my present home in Redlands, sixty miles east of The Huntington and on timetables of the PE in the heyday of salubrious citrus excursions. The tracks in this photo were once Santa Fe, which entered town from San Bernardino to the west. PE had its own line entering town on the main drag from the north and winding through posh Smiley Heights on the

southwest side; none of those tracks survive to this day. The ex-Santa Fe line is now earmarked for Metrolink service which, despite extant roadbed, station and hopeful hype is quagmired in money and politics. Yesteryear, in a quickly betrayed golden age of people movers, this Huntington-o-phile could have walked less than a mile downtown, boarded a Big Red Car and ridden nonstop to within three blocks of the estate. Now? Rent a car and battle freeway gridlock, usually both ways, for an uncomfortably cramped respite on the ranch between rush hours. Such is the price of the great American automotive predation by luxury that forever derailed trolleydom.

Three weeks after I took this picture, the little tree was gone. These rails were last polished by wheels nearly two decades ago, and connection of this outpost to the rest of the commuting world may await magnetic trains. But trees weren't to foul the way. When H. E. proclaimed money had nothing to do with it, he was, for a moment, re-illuminating progress. He didn't live to see what progress was to do with him.

Page 39 *The Huntington Mausoleum*
art 170629 1_3, photograph, 2013

Few could argue that the destruction of the great Royal Library of Alexandria decidedly changed the course of human history. Over many subsequent generations knowledge had to be re-sown on new fields. Thus, Huntington and his own estate and library are as we know them today.

There was a Guiding Hand in the things that H. E. Huntington bequeathed to us, providing insight in his wages tempered but not enslaved by capitalistic achievement. This gift was two-fold. Firstly, the concept and vision of the Pacific Electric system was indeed magnanimous. It should not be considered that, in the urban dysfunction of our times, we have suffered the wrath of our giver but only the consequence of an oversight of gratitude in our excess. And secondly, whatever its gathering of priceless antiquities The Huntington, or any great institution, cannot be reparation for the reckless extinction of human quest at Alexandria. Rather, it is a history of consequence, and at every step it is our spirit, not the most oaken accomplishments, that are our legacy, and that the most sincere part of The Huntington.

I never rode a Big Red Car or even planted a palm tree. In my humble approach to the mausoleum, I become more aware of a halcyon abandon from the surrounding world – the hordes of idolizers of *Pinkie* and *The Blue Boy*, the lovers of lotus, the children blowing down in the nearby science garden – among whom Huntington's favorite lemon-scented gums have no knowledge. I am reminded of an inscription from the reading room at Alexandria: "The place of the cure of the soul". In all its many offerings and virtues, could the true gift of The Huntington be any less?

The Huntington

The Huntington Library, Art Collections, and Botanical Gardens, the subject of this book, is a cultural institution located in San Marino, California. It was the retirement estate of Henry E. Huntington and his second wife Arabella, begun in 1903 on the property of former San Marino Ranch owner James De Barth Shorb. As a real estate and railroad magnate and a pillar of development in early twentieth-century Los Angeles, Huntington enabled us the Pacific Electric, whose iconic "Big Red Cars" epitomized a sadly short-lived interurban empire that has never since been equaled. Sharing a common interest, H. E. and Arabella amassed an impressive collection of early American and European art, antiquities, and a library of historic documents and literature spanning a major portion of written history. For decades, the gardens have been a working research showcase of the art and technology of urban cultivation. Huntington established a trust for perpetuity in 1919 and the estate opened to the public in 1928, a year after his death. It has grown ever since to become a major local attraction and a world leader in literary research, scholarly support, and cutting-edge botanical science.

Technique

All the images in this book are by me, although several photos included art or architecture that is within the collections of The Huntington. My photographs were taken with one of two cameras, a Nikon Coolpix L820 and a Canon Vixia camcorder. All the drawings and paintings were made freehand in software, some using photos only as a model for accuracy. Many include altered photos. As an artist, two things I do not are to trace photos directly (kids playing pirate), or to use automatic digital processes to make workless, and worthless, instant "masterpieces". My compositions utilize a number of digital processes but most importantly creative eye-to-hand work.

Who's in the pictures?

My fictional protagonists appear in some drawings and cartoons. Three of them are a Huntington sorority, the "Tristerhood", comprising Monikka, Queen Smettie, and Namiko. The first two are supernatural. Monikka, a dark-haired Hindu-Pole who is a brilliant scientist, has magnetic properties and sunspots on her dress. The Queen, a billionaire with a heart of gold and her giant hair cones filled with The Huntington's lavender, was transported here in a time warp from an affluent principality in another universe. Japanese Namiko is a retired geisha whose restless intellect inspired travel and exotic camaraderie. What keeps these Rogatero mavens together is the strong nuclear force – their unassailable compassion and open-heartedness to one another and all.

Bokkies are ephemeral spirit beings that emerge from lotus buds. Founts of kindness and goodwill, they are products of a Christian kingdom ruled by The Big Banjo Strummer and his divine son. Bokkies float in the air and approach mortals exhorting prayers in return for gifts. The name "bokky" is a sci-fi twist; infinite in number, they are souls of the doppelgangers of Monikka that populate the multiverse. Bokky was Monikka's schoolgirl nickname.

So what are seeds?

They are little cards with art and inspirational quotations printed on them. It is a RAKSAB concept I began in 2014, and it continues as a self volunteer venture. The world reserves no spot for random acts of kindness and senseless acts of beauty, so they must be bold outlaws wherever they manifest themselves. Seeds are gifts of goodwill, sown hither and yon with only the hope that each sprouts in a cortex on its way to a wastebasket. Every image in this book marked "seed" has appeared at one time or another on a seed, many having invaded The Huntington.

www.ingramcontent.com/pod-product-compliance
Lightning Source LLC
Chambersburg PA
CBHW041109180526
45172CB00001B/172